IMAGES
of America

FALLBROOK

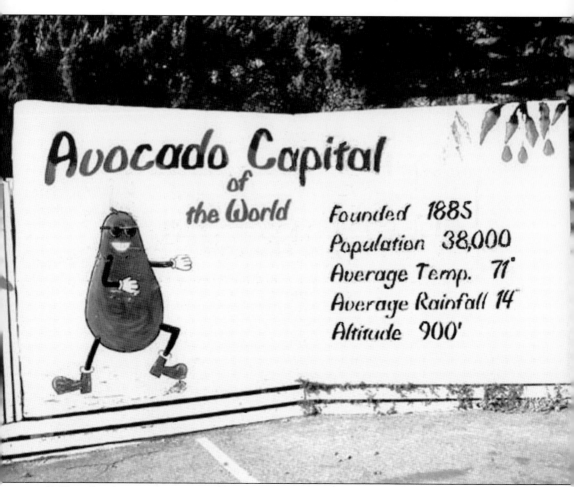

Fallbrook is known foremost for its avocados, so this sign says it all. Located at the REMAX realty office on South Mission Road, it welcomes visitors to Fallbrook, the Avocado Capital of the World. (Photograph by author.)

ON THE COVER: Workers at the Fallbrook Olive Packinghouse posed outside their workplace at 215 West Fallbrook Street for this 1916 photograph. The only person identified is Eric Hindorff, who is the tallest man, near the crates in the back row. (Courtesy of FHS.)

IMAGES
of America

FALLBROOK

Rebecca Farnbach and Loretta Barnett

ARCADIA
PUBLISHING

Published by Arcadia Publishing
Charleston SC, Chicago IL, Portsmouth NH, San Francisco CA

Printed in the United States of America

Library of Congress Catalog Card Number: 2006941043

For all general information contact Arcadia Publishing at:
Telephone 843-853-2070
Fax 843-853-0044
E-mail sales@arcadiapublishing.com
For customer service and orders:
Toll-Free 1-888-313-2665

Visit us on the Internet at www.arcadiapublishing.com

We dedicate this book to Margaret Hindorff Ray, an unofficial historian and archivist who has preserved photographs, documents, artifacts, and stories of her ancestors and others who settled in Rainbow and Fallbrook. Without her assistance and resources, this book would not have been possible.

CONTENTS

ACKNOWLEDGMENTS

Unless noted, all photographs presented are from the Margaret Ray family collections. Donations from the Fallbrook Historical Society are marked FHS. We thank Margaret for providing her personal photographs and for formatting all the photographs presented to meet publishing specifications. We appreciate the generosity of the Fallbrook Historical Society and Stephen and Rosalie Garnsey, who opened their albums to us. We also thank the Ludy family for their contributions to this volume. We would like to express our gratitude to proofreaders Darell Farnbach, Malcolm Barnett, Dick Fox, and Bill Harker.

If you wonder why certain events or individuals are not presented in this book, it is because we attempted to tell the story of Fallbrook and communities in its sphere of influence using the photographs we had access to. We have opted to cover only the community histories and to not include the extensive military history, which is presented in other volumes.

If you have historical photographs or information to share, please contact the Fallbrook Historical Society at (760) 723-4125.

INTRODUCTION

When the Reche family arrived in the Fallbrook area in 1869, they found evidence of previous occupation by Native Americans whose diet depended on the acorns harvested from the live oak groves. The waterfall on the Reche homestead inspired Vital Reche to call the area Fall Brook, the name of a town they had lived in near Pennsylvania. Soon the entire area was called Fall Brook.

The area is still known for its produce, first started by the Reches. They planted fruit trees and grapes and had a 130-colony apiary. When they arrived, the woods were full of grizzly bears and herds of deer, and it was not safe to travel after dark without a rifle.

Surveying of the land began in 1869, offering opportunities to homestead, and a trickle of settlers came. Vital Reche's brother came and homesteaded an adjacent property, and before long, his wife's brother Henry Magee came and homesteaded farther west. There were three families, with a total population of 20. The region Magee settled was referred to as West Fall Brook.

In 1875, when the County of San Diego chartered the Fall Brook School District, the Reches held classes in their home. By 1876, there were 14 families and a total of 60 people in the district. The first schoolhouse was constructed in 1880 to serve the 25 families now living in the district.

In 1887, Reche opened a post office and voting precinct in his store, where he sold grocery staples and honey from his bees. He shipped his Fall Brook Honey all across the country. Sometimes he carried a wagonload of honey jars to San Diego with a four-horse team.

After the railroad came near West Fall Brook in 1882, a real estate boom started. The floodgates opened, and people came from the East to buy ranches and town lots. By 1885, West Fall Brook was laid out in tracts and lots, from Elder to Kalmia Streets and from Hill to Vine Streets, becoming the Fallbrook we know today.

When Reche's post office closed in 1888, the West Fall Brook Post Office dropped the "West" from their name. During the early 1900s, people began to condense the name to one word, Fallbrook. In the mid-1940s, one of the Fall Brook postmasters decided to make "Fallbrook" the official name. "Fallbrook" is used exclusively in this book, except to refer to institutions or proper names recorded as "Fall Brook."

Today the "Friendly Village" offers culture in its art galleries and nature's beauty in its wildlife preserves. The pleasant climate of the rural countryside still attracts newcomers.

One

EARLY FAMILIES

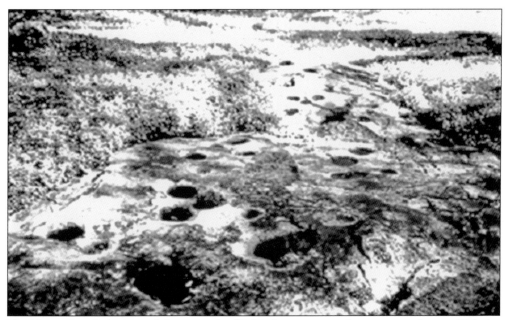

Used by early inhabitants of the area, this bedrock mortar grinding stone with over 20 holes remains as a reminder of the people who resided here in harmony with nature. Located at the Reche School, it has summoned imaginations and provided inspiration for several generations. An expert estimated it was used over 1,000 years ago.

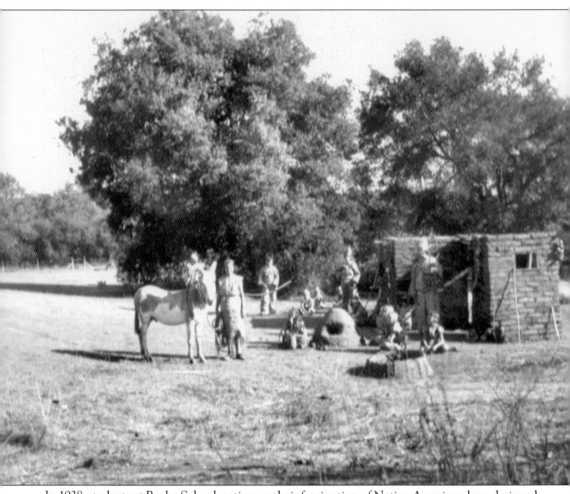

In 1938, students at Reche School, acting on their fascination of Native American lore, designed a set and wrote a play about life in a Native American village. With a little guidance from their teacher, the students constructed an adobe dwelling and outdoor oven, made costumes, and brought pets to serve as animal actors.

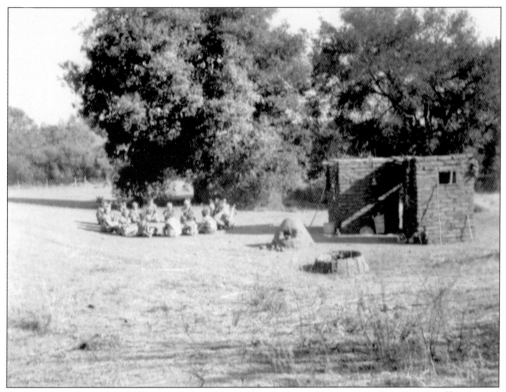

In this scene from the 1938 play, the students sit cross-legged in a council circle. A doll strapped to a papoose board is near the door of the adobe. The play, produced by the students, generalized the Native American experience; however, instead of keeping true to the local culture, they added practices of the Southwest and Plains Indians.

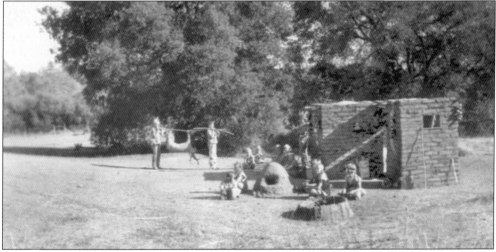

In this scene, titled "Bringing Home the Kill," students dramatized how two young braves would bring a deer back to the village for use as food, clothing, and cording. They made the deer by stuffing burlap sacks with crumpled newspapers and attaching antlers borrowed from Eric Hindorff. A bunch of native gourds hung to dry at the side of the adobe. Margaret Hindorff, as the "chief," sang a hunting song she and her father wrote as a prayer for good hunting.

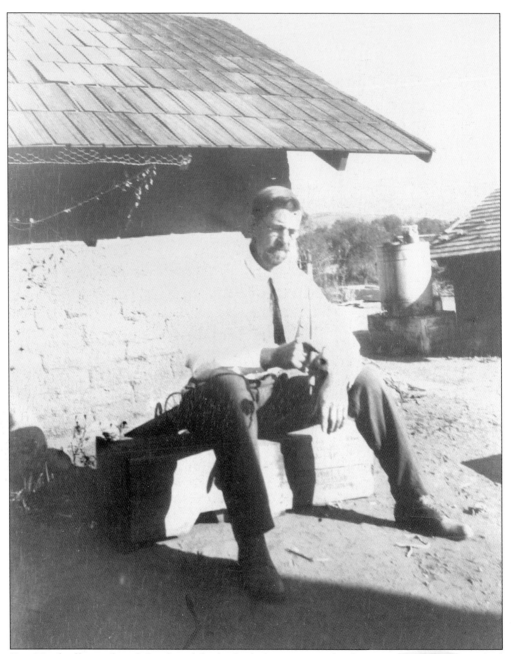

Eric Hindorff, on a bench by the adobe he built for storage at his home on Gird Road, smoked an Native American pipe shaped from lava rock he found in his extensive travels through Southern California. He enjoyed associating with Native Americans and treasured the relics he collected.

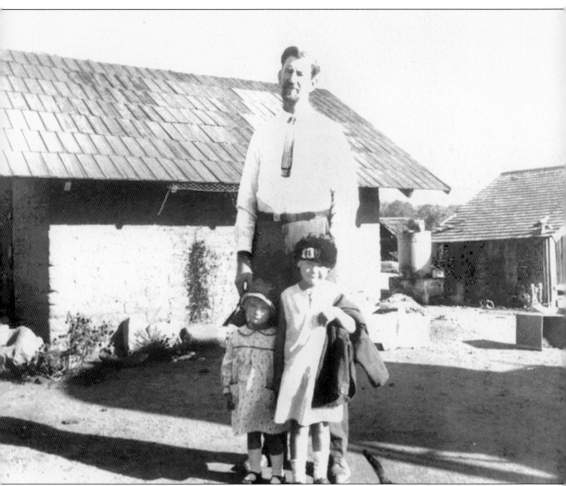

The presence of *metates*, portable grinding stones, like those lined up against the foundation of the Hindorff adobe, reminded Fallbrook residents of earlier occupants of the area. Frances and Margaret Hindorff posed with their father Eric in this 1929 photograph.

Vital Reche homesteaded in the region in July 1869, naming it Fall Brook for the cascading 20-foot waterfall near his home. He opened a store, and later a post office and voting precinct in 1887. When the San Diego Board of Supervisors established the Fall Brook School in 1875, classes met in the Reche home. (Courtesy of FHS.)

Charles Reche, son of Vital and Amelia Magee Reche, lived for a longtime on part of his parents' 160-acre homestead, which included Live Oak Park alongside a creek his father named Fall Brook Creek. His parents came from New York State after hearing about the attributes of this region from Amelia's brother Henry Magee, a soldier in the Mexican-American War in 1847. (Courtesy of FHS.)

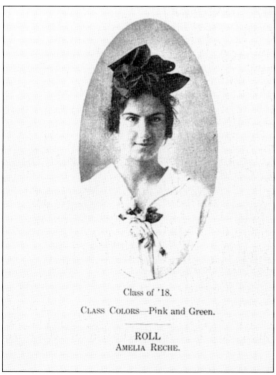

Class of '18.

CLASS COLORS—Pink and Green.

ROLL
AMELIA RECHE.

The Amelia in this photograph was the granddaughter of Vital and Amelia Magee Reche and the daughter of Charles Reche. A county school nurse who never married, she was killed in an automobile accident in the 1930s. (Courtesy of FHS.)

15

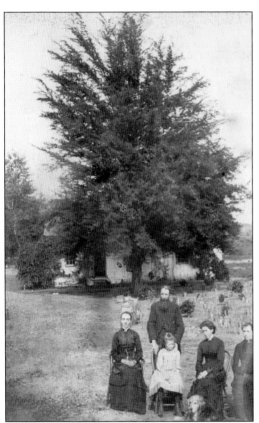

This family sitting in front of this home is likely the Reche family, who farmed alfalfa, strawberries, and other produce. They established the first area post office, grocery store, and stage stop. Their Fall Brook sage honey was legendary. The family opened Reches' Retreat, a hostelry that welcomed seasonal guests and land speculators. (Courtesy of FHS.)

The Reche home was once the center of activity in Fall Brook. The family came from near a town called Fall Brook, Pennsylvania, and after seeing a cascading waterfall here, adapted the name. Live Oak Park was formerly known as Reches' Grove. Vital Reche's brother Anthony and his family homesteaded an adjoining 160 acres. Amelia Magee Reche's brothers Henry and John Magee settled farther west on the mesa. This photograph was taken around 1967. (Courtesy of FHS.)

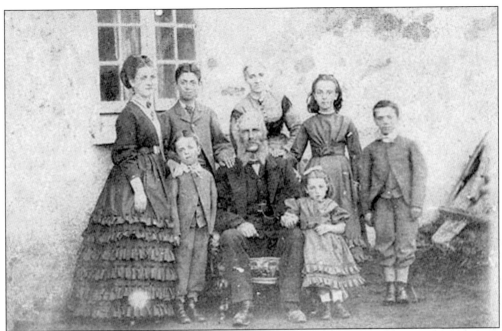

The people in this unidentified photograph from the Jack Magee file at the Fallbrook Historical Society are presumed to be Henry Magee and his family. Magee, a veteran of the Mexican-American War, inspired his sister Amelia and other family members to settle in Southern California. Henry's wife taught school for a while in their home near the Santa Margarita grant, which included the village of Fall Brook. (Courtesy of FHS.)

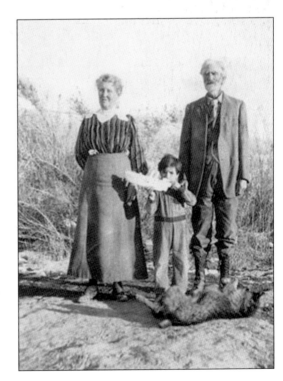

In this, another unidentified photograph from the Jack Magee file, it looks like the same man and woman as in the image above but at a later time. Perhaps they are posing with a grandchild. In 1881, when the railroad construction approached, residents joked they were about to emerge from the backwoods into the daylight of civilization. (Courtesy of FHS.)

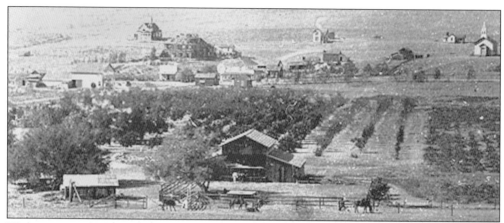

This overview of Main Street in 1894 shows the Bartlett family's large barn in the center, adjacent to rows of fruit trees. The two-story building in the back left of the photograph is the school. (Courtesy of FHS.)

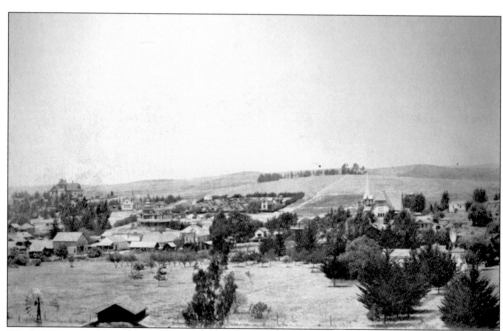

This 1900 overview of the town of Fallbrook shows several buildings in detail— Bartlett's barn, the Naples Hotel, the Methodist church, the Baptist church, and the old high school. (Courtesy of FHS.)

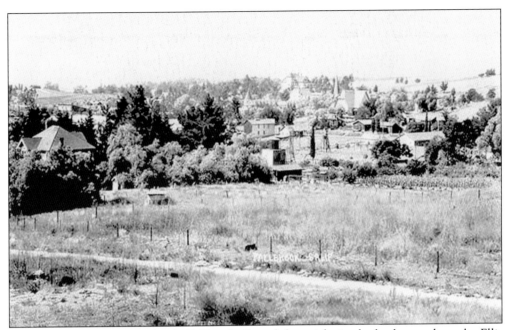

This is another overview of early Fallbrook. From left to right in the background are the Ellis Hotel, the two-story school, Masonic Hall, and the Baptist church. (Courtesy of FHS.)

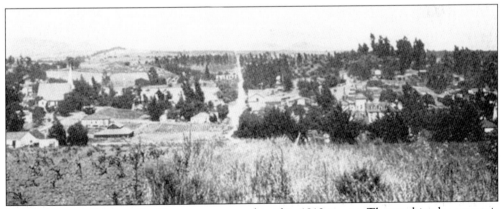

The quietness of the rural village was captured in this 1910 image. The road in the center is Alvarado Street, heading toward Palomar Mountain in the background. In 1916, Fallbrook was praised for being the original "dry" town in this part of the state, not having had a saloon for the past 20 years. (Courtesy of FHS.)

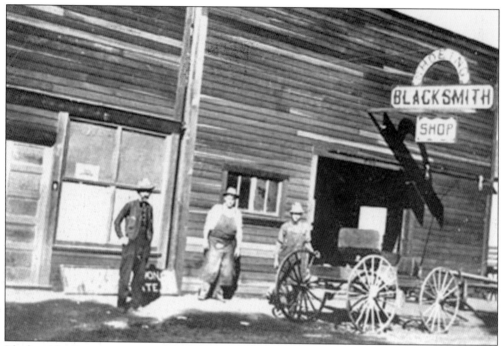

Blacksmiths were as important in yesteryears as mechanics are today. They fabricated all sorts of metal components for machinery and other items, such as bridle bits. In addition, they shoed horses, repaired wagons, and often operated liveries where horses and buggies were rented to visitors who arrived by train. (Courtesy of FHS.)

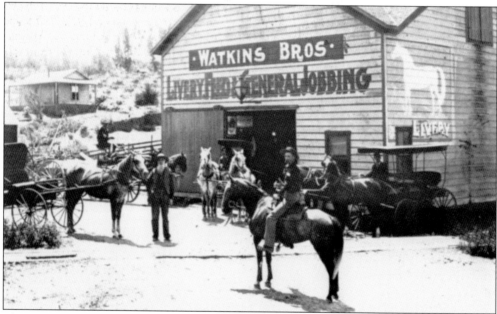

The Watkins brothers operated the livery station featured in this *c.* 1912 photograph. They sold livestock feed and contracted labor for various jobs that required horses. The livery was on the south side of the 100 block of East Alvarado Street. The cottage seen on the hillside once belonged to Lula Perigo. It is still standing and is now a quilt shop. (Courtesy of FHS.)

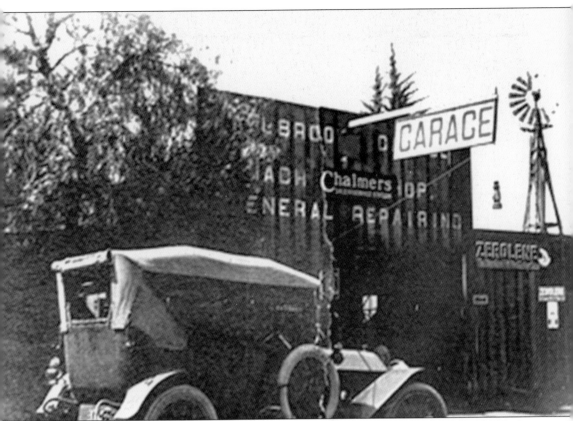

The Fallbrook Garage, owned by Frank Day of DeLuz, located on the east side of the 100 block of South Main Street, did general automotive repair and sold zerolene gasoline. Garages like this often started as livery stations and blacksmith shops, then as demand dictated, they transitioned to mechanical work and gasoline sales. (Courtesy of FHS.)

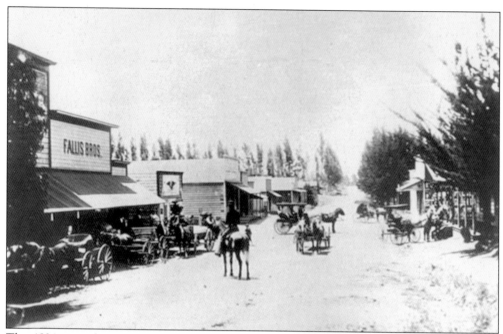

This 1894 view of Main Street shows the Fallis Brothers General Store and a flurry of activity on the unpaved street while a lone horseman watches several horses and buggies. Concrete sidewalks and curbs were put in several years later. (Courtesy of FHS.)

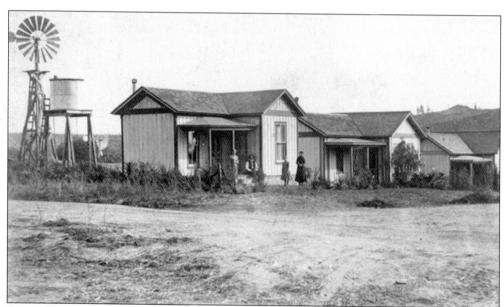

Pictured are three early homes in Fallbrook, all of which are still standing on the south side of East Mission Road between Iowa and Orange Streets. Jack Cornell, a volunteer fireman, and his family lived on the corner and had an electronic business there for several years.

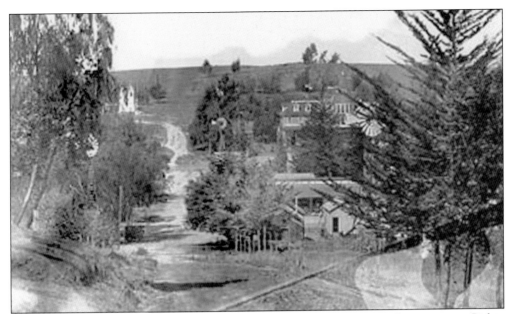

The three windmills in the photograph demonstrate how water was pumped in times past. Before municipal water districts were formed, every home had a windmill and water storage tank for their household use. This is how Fallbrook looked from a hill east of Main Street. (Courtesy of FHS.)

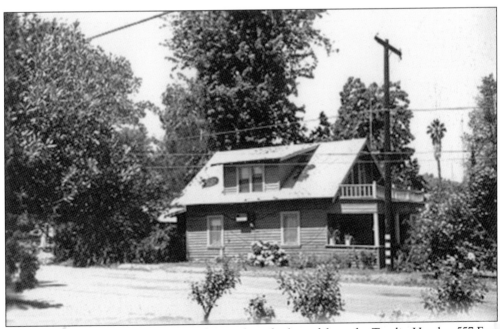

The Brandon House was built in 1911 from redwood salvaged from the Tomlin Hotel at 557 East Alvarado Street. It is still standing on Brandon and Alvarado Streets. (Courtesy of FHS.)

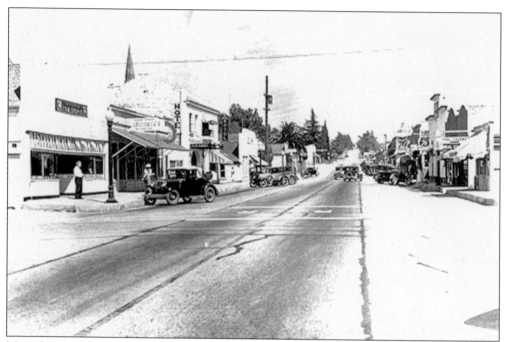

Main Street was transformed when the streets were paved and automobiles came into vogue in this c. 1930 photograph. Down the street were Larry's Café and a pool hall. The road was wide enough for angle parking. (Courtesy of FHS.)

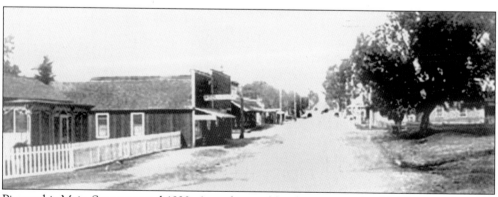

Pictured is Main Street around 1920. A poolroom, like the one seen in this photograph, was a place for leisure time and socializing in the era before television. (Courtesy of FHS.)

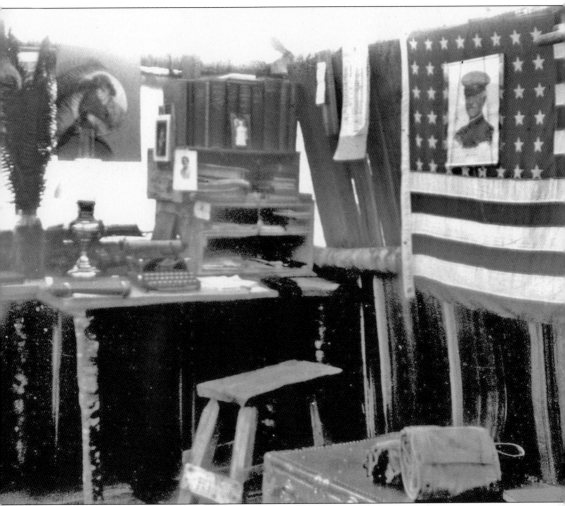

This *c.* 1920 photograph shows a primitive office with an old typewriter, stacking files, and a photograph of a soldier attached to an American flag. It is speculated to be the office of William E. McEuen, who wrote columns in the *Fallbrook Enterprise* and many wonderful stories about early days in the West.

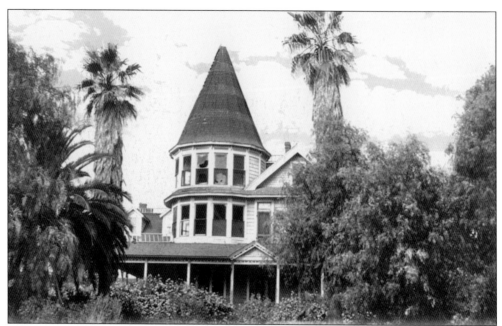

This hotel was first called the Naples Hotel and was operated as a health resort. In 1911, when William Ellis purchased the hotel from the Russ Lumber Company of San Diego for $6,000, he renamed it the Ellis Hotel. His ranch supplied produce and game for the dining room. The rate was $2 per night for room and board. (Courtesy of FHS.)

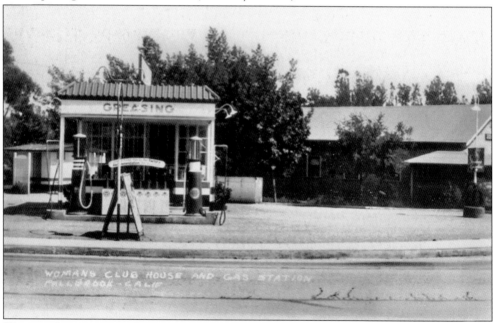

This gasoline station with mechanical pumps stood next to the Women's Club House at the southeast corner of North Main Street and Juniper Street, which has been renamed East Mission Road. Gasoline cost about 15¢ per gallon and was hand pumped into the glass reservoir at the top of the pump, where the customers could measure the amount before draining it into their cars. This photograph was taken in 1939. (Courtesy of Pomona Public Library.)

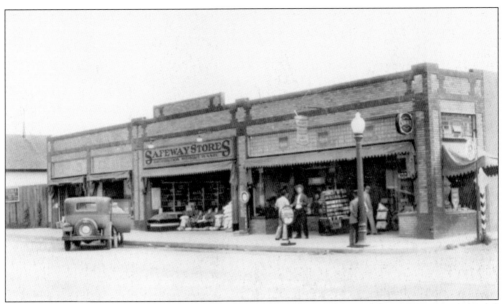

In 1939, markets like this one did not have large parking lots in front of them. Meat was selected from a display behind glass and weighed by the butcher. When supermarkets came into vogue in the 1960s, shopping for food changed. Shopping carts were used, and more merchandise was offered, with much of it processed and prepackaged. Note the men stood in front of the pharmacy next door, while their wives shopped. (Courtesy of Pomona Public Library.)

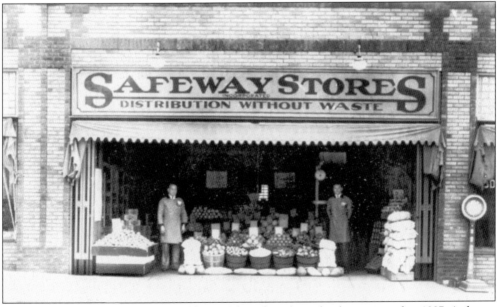

The Fallbrook Safeway Store offered beautiful produce from the day it opened in 1927. As home refrigerators became more common, women began to shop once a week instead of every day. Scales, like the one to the right of the entrance, gave patrons an opportunity to weigh themselves and to look in the mirror for the cost of one penny. (Courtesy of Pomona Public Library.)

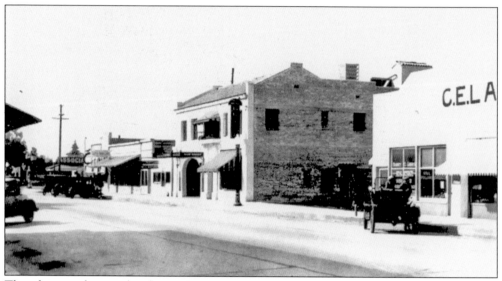

This photograph was taken by Frashers Foto of Pomona, California, in 1939. Looking south on Main Street, the street looks nearly empty in front of C. E. Lamb's store and the El Real Hotel. After the hotel went out of business, it housed several enterprises, including the Packing House Restaurant and presently an Irish pub. (Courtesy of Pomona Public Library.)

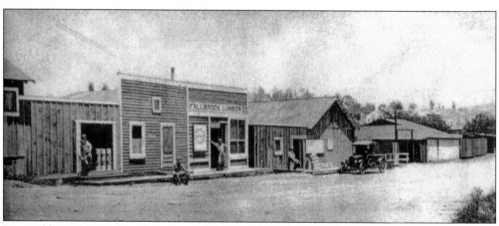

Pictured here is the Fallbrook Lumber Company, which predated the Hayward Lumber Company. A lumber company was important business in times past. Men would design buildings, calculate how much lumber and other materials they would need, and then go to the lumber company to get it. (Courtesy of FHS.)

Two

TRAINS

In 1881, railroad developers surveyed the eastern Fallbrook area, where Interstate 15 is now, to construct a connection between the Southern California coast and the transcontinental railroad. The Eastern engineers, unfamiliar with the area, chose a route along the Santa Margarita River through the Temecula Canyon, placing the tracks just a few feet above the riverbed. Locals asked them to reconsider, pointing to water marks on the canyon walls much higher than the tracks, but the engineers, who believed the dry river would never carry much water, proceeded with construction. (Courtesy of FHS.)

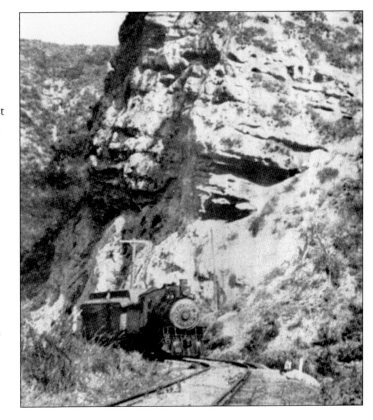

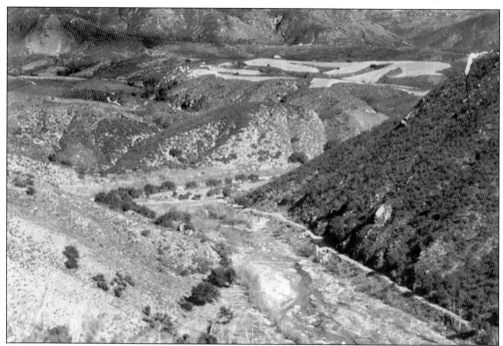

Seen here is the Santa Margarita River looking upstream toward Temecula. Four floating railroad bridges, constructed between the Fallbrook Station and DeLuz, swung downstream in high water, yet stayed attached to pilings. When water receded, they were pulled back in place. (Courtesy of FHS.)

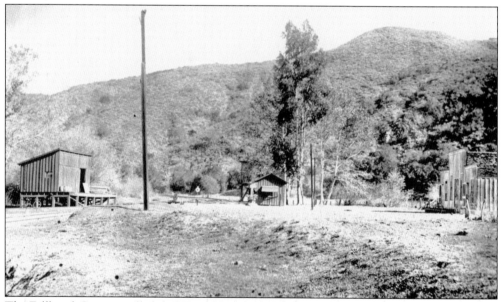

The Fallbrook Station, called the "Howe Station" of the Santa Fe line, was located just north of the intersection of DeLuz Road and Sandia Creek Drive, one and a half miles north of Fallbrook. This 1895 photograph shows the station, which was the end of the line going north from Escondido via Oceanside after the 1891 washout in the Temecula Canyon. (Courtesy of Fallbrook Union School District.)

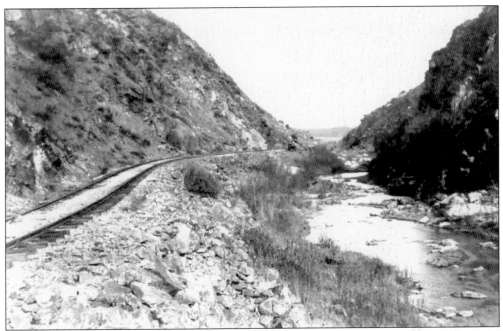

This photograph demonstrates how close the tracks were to the water. Accounts reported beautiful scenery on the trip through the Temecula Canyon, before floods washed out the tracks in 1883 and 1891. The rail line was not rebuilt after the 1891 flood. Had the engineers listened to local residents, the railroad would have been constructed elsewhere. Rail service to San Diego continued south of the flooded tracks in Temecula Canyon. (Courtesy of FHS.)

Flooding from a storm in 1916 caused extensive damage to the railroad line between Fallbrook and DeLuz, leaving about $25,000 worth of equipment standing. The group with the lowest bid—$6,000—received the salvage contract. Five men and four horses brought everything salvageable out of the canyon. (Courtesy of FHS.)

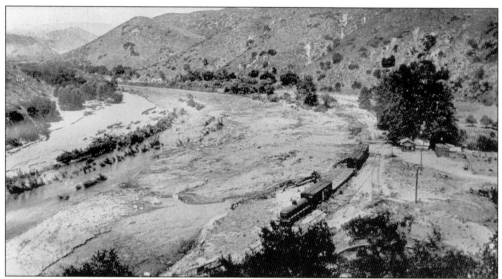

The Santa Margarita River, swollen during the vicious 1916 storm, wiped out the Santa Fe Railroad tracks through the canyon, dumping tracks and railcars into the torrent. Newly exposed bedrock pitted with Native American grinding stones testified to the early inhabitants of the canyon. (Courtesy of FHS.)

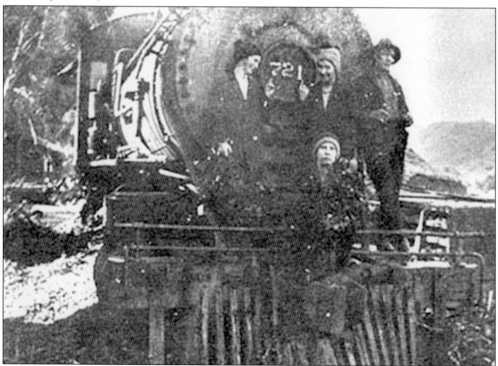

Pearl and Eric Hindorff and two unidentified friends, from left to right, hiked into the Temecula Canyon to see stranded Locomotive No. 721. Originally a passenger car carried travelers, but they later rode in the caboose. Passenger service ended in the early part of World War II when the line carried military supplies to the Ammunitions Depot, now called the Naval Weapons Station. It continued as a freight line. (Courtesy of FHS.)

After the 1916 flood, Eric Hindorff went by horseback across the swollen Santa Margarita River to assess damage. A house moving company from Pasadena won a contract to salvage the engines, cars, turntable, and other scrap within 90 days of signing the contract. (Courtesy of FHS.)

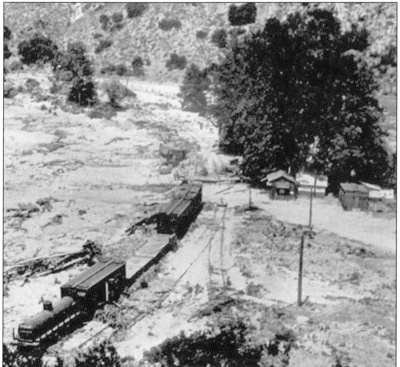

This shows damage to the tracks, the Howe Station, and surrounding buildings after the flood. Stranded Locomotive No. 721, weighing 80 tons, posed problems in extraction. All together, the equipment salvaged weighed 400 tons. (Courtesy of FHS.)

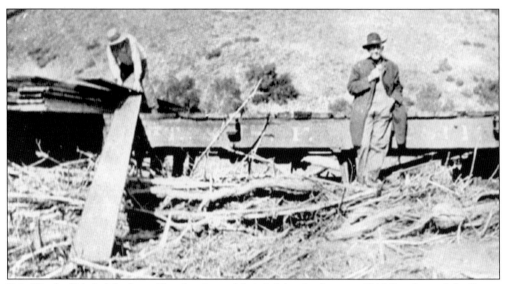

Eric Hindorff, left, lifted good lumber from debris left by the January 1916 flooding of the Santa Margarita River. Constable Bill Fleshman stands at right. Train cars were raised from their sides and precautions were taken to prevent damage or injury. Equipment was wired to ties, chocks, and rails to prevent loss while they were navigated up steep embankments. (Courtesy of FHS.)

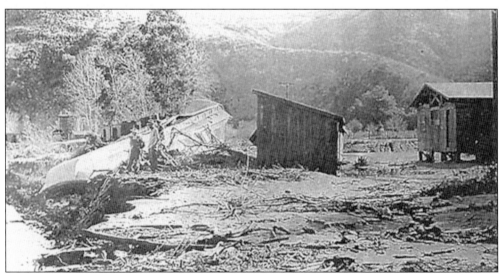

A group of unidentified men surveyed damage from the flood, which destroyed Fallbrook's Howe Station near the intersection of DeLuz and Sandia Creek Roads. The top of a train car sticks out of the mud along the left side of the photograph. (Courtesy of FHS.)

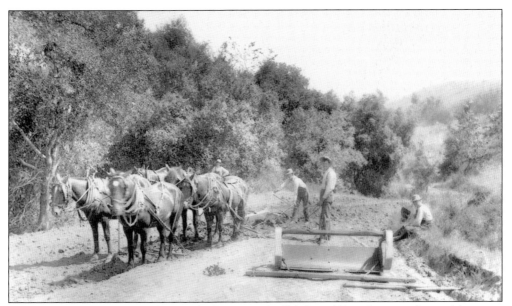

Constable Bill Fleshman, right, watched Eric Hindorff, left, and Bert Stewart, the road foreman, widened and straightened DeLuz Road. They prepared the roadbed to haul Engine No. 721 from its stranded location in the canyon to Fallbrook, where a new station would be built. Fifty-pound rails, attached to ties and set in front of the equipment on the road, allowed four horses and two capstans to pull a heavy load six feet per minute up the 14-percent grade into town. (Courtesy of FHS.)

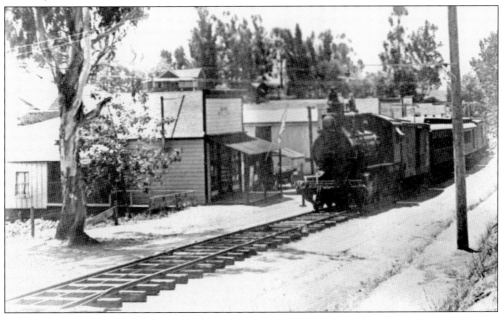

Train tracks were installed on Main Street in Fallbrook to bring the recovered engine to town. A new "surf" line was established between Oceanside and Santa Ana, and a connection was built from the surf line to Fallbrook. Because there was extra room at the end of the line in Fallbrook, the train was turned around on a triangle instead of a turntable. The Citrus Association Packing House was its largest client. Other clients were the lumber and oil companies. (Courtesy of FHS.)

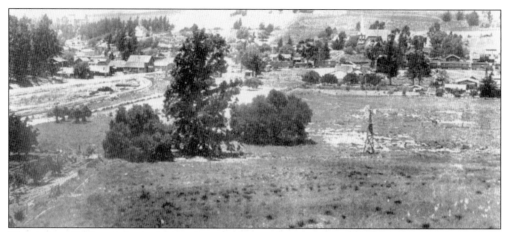

This is how Fallbrook looked from the east during the summer of 1917, while the new railroad station was under construction. Howe Station, near DeLuz and Sandia Roads, served Fallbrook until it was washed out. When the train cars were salvaged from the canyon, they were brought into town to wait until new tracks were laid. (Courtesy of FHS.)

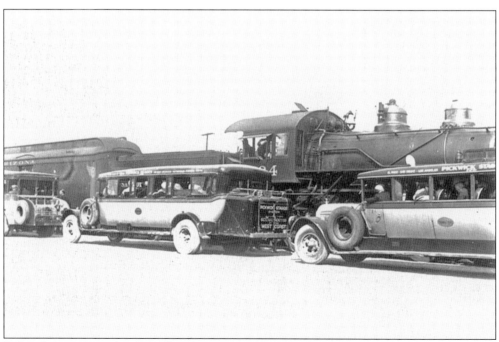

Pickwick Stages waited at the Fallbrook Station in 1928 to carry passengers on overland excursions, similar to chartered bus tours of today. The train station featured a large office in the center, with freight and storage rooms, and a potbellied stove warmed the good-sized waiting room. People could see the telegraph agent tapping out and receiving messages in his office. (Courtesy of FHS.)

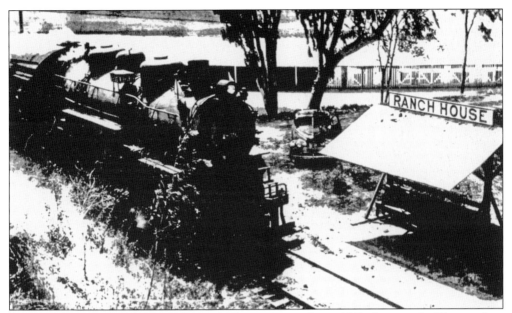

A locomotive stood at the O'Neill Ranch House stop in this c. 1941 photograph. The new line went past the ranch house, past Lake O'Neill, up a steep 14 miles to the Naval Weapons Station, and continued into Fallbrook. The ranch house is now the commanding general's quarters at Camp Pendleton. (Courtesy of FHS.)

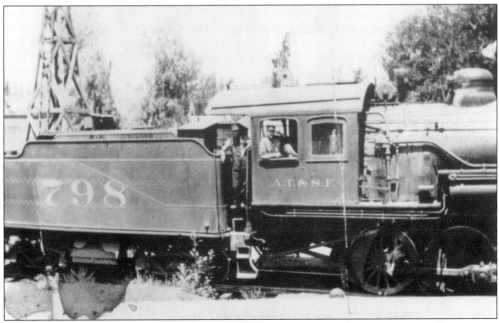

Santa Fe Engine No. 798 was the first engine to enter the area on the new Fallbrook Branch line on July 1, 1917, on recently built tracks. After the January 1916 storm, stalled Engines No. 800 and No. 721 were brought to South Main Street off Fig Street with the stranded train cars. They were eventually hauled away. (Courtesy of Maie Ellis collection.)

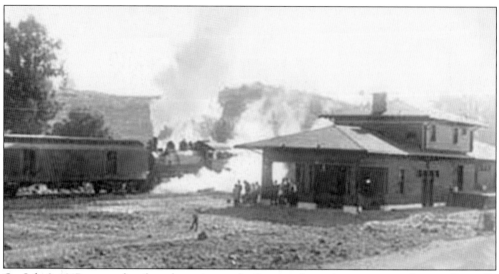

On July 9, 1917, a crowd gathered to witness the first regular train arriving at the new Santa Fe Depot on Alvarado Street. It departed from the original grade near Lake O'Neill at what is now Camp Pendleton. The train made travel more accessible and allowed for easier shipping of local produce. (Courtesy of FHS.)

The tall palm trees marked the Fallbrook Depot on Alvarado Street. F. McMillan, the first depot agent, lived upstairs with his family in a large apartment. He served previously at the Howe Station, which washed out in 1916.

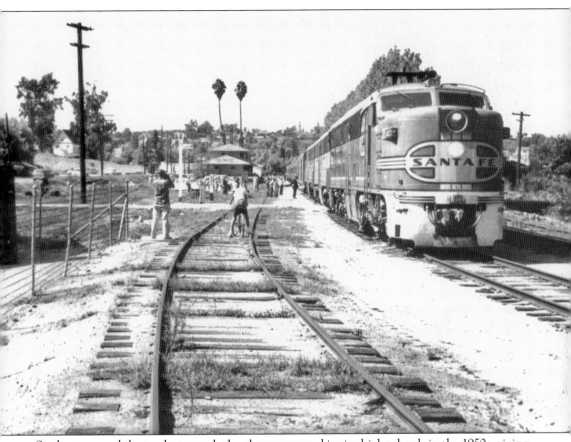

Students crossed the tracks to reach the elementary and junior high schools in the 1950s, giving them a sense of danger and a thrill at being so close to the powerful machinery. The high school was just across the creek from the station; many students took a shortcut down the tracks to school. (Courtesy of FHS.)

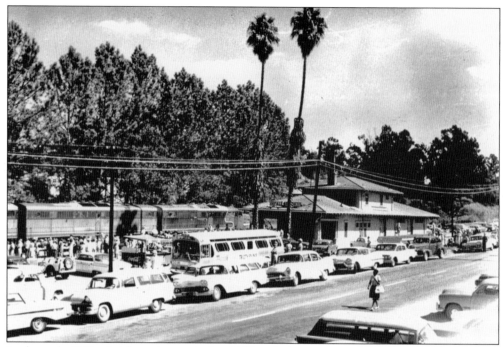

In the early 1960s, freight trains arrived in Fallbrook three times a week. The Fallbrook Citrus Association's Sunkist packinghouse closed in the 1970s, leaving the railroad without any Fallbrook customers. The depot was demolished in 1971, and after the roadbed washed out in Camp Pendleton in 1982, the tracks were removed. (Courtesy of FHS.)

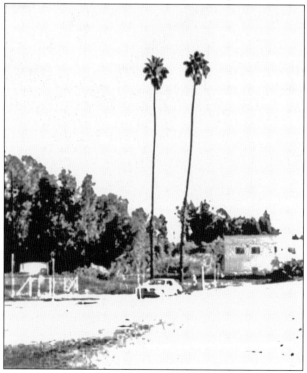

This photograph shows the Fallbrook Station's palm trees in 1996. The palms, now gone, were planted in 1917. People in the community wanted to preserve the palm trees for use at either the new sheriff's station or at the museum, but the trees were too unstable to replant. Members of the Fallbrook Historical Society harvested some of the palms' offspring and planted them at the museum.

Three

RANCHES
AND AGRICULTURE

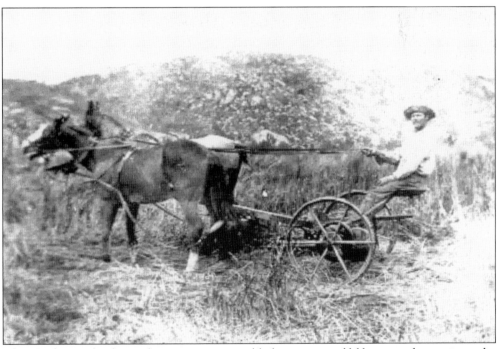

Chris Ludy ran this horse-drawn mower, or sickle bar, cutting alfalfa or another grain at the Gould Ranch in Rainbow, California, in 1902. The Ludy family farmed the Pauba Ranch in the Temecula area before selling it to Walter Vail and his partners in 1905. Agriculture has been the predominant industry in the Rainbow, DeLuz, and Fallbrook areas since settlement in the 1800s, first with homesteads and family farms, then in agricultural business operations. Before the formation of irrigation districts, which drew water from rivers and creeks, settlers had dry farms—raising cattle and producing grain. Afterward honey, olives, citrus, avocados, and wholesale nursery plants became cash crops. Today Rainbow is known for its plant and flower nurseries.

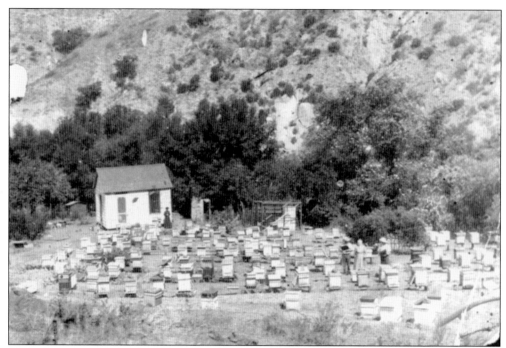

From the time Reches settled the Fallbrook area, it was known for its fruit trees and honey. This 1911 photograph shows the extensive apiary Mary Gird Peters owned. Initially, honey was sold in quart canning jars in the local area, but after the train came, it was shipped in five-gallon tins, two per crate, across the United States. (Courtesy of FHS.)

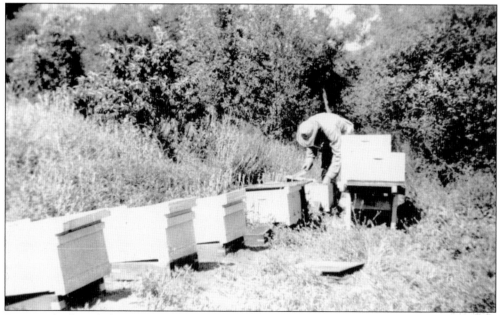

Eric Hindorff tended several hundred stands of bees throughout the North County region. He was a deputy county bee inspector for a number of years and always kept a few stands of bees, as seen here in the 1960s. In 1911, Fallbrook bee ranches produced 2,500 cases of comb honey and 30 tons of a fine quality of extracted honey.

Jean Lamb held bunches of grapes her uncle Murray Lamb harvested in Fallbrook in the 1930s. More grapes are in a crate beside her. Box-maker Ray Peters made Fallbrook Citrus Association crates by hand for 30 years, but he did not make lug boxes. While neighboring Temecula is now known for its vineyards and wineries, Fallbrook and DeLuz have always been identified with table grapes.

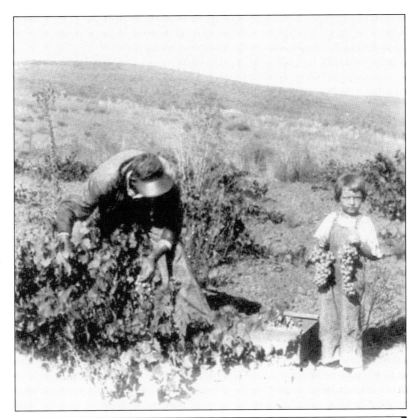

SWEET MUSCAT GRAPES

From DE LUZ CANYON

Grown Without Irrigation

F. R. GARNSEY

The Garnsey family settled in the DeLuz area in the 1880s and ran an agricultural business. They sold their produce to markets in Murrieta and Santa Ana until grocery store chains dominated the marketplace in the 1960s. This box label advertises sweet Muscat grapes grown without irrigation. While the primary business of the Garnseys now is growing gourds, they continue to produce grapes for their own enjoyment. (Courtesy of the Garnsey family.)

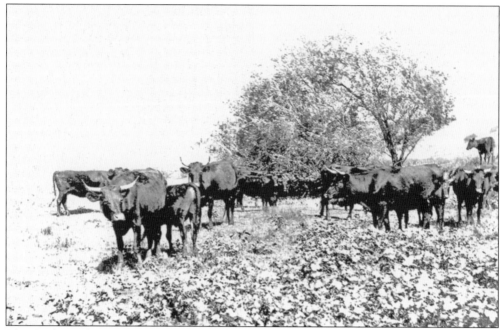

The Gird's cattle are seen on their ranch in the 1920s. It was common for neighbors to loan farm equipment to each other or to partner in buying large equipment. Here is a quote from an amusing note to D. O. Lamb, "Mr. Lamb, As I spoke to you for the use of your corn planter, will you leave word at the Lamb Store when you are through with it? Yours Truly, C. Bartholomew."

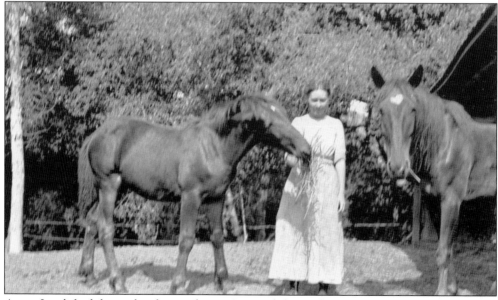

Annie Lamb feeds hay to her favorite horse, Actor, while another one of the family's horses waits for attention. Not only did these horses have glossy coats, they also had distinctive markings. Note Actor's diamond-shaped mark and the other horse's heart-shaped mark. Families would groom their horses for show, just like families today wash their cars to look good in public.

This is Pansy, the Garnsey's milk cow, also known as "Old Faithful." Every family needed a cow to supply milk, cream, and butter for their household needs. Along with the advantage of owning a cow came the responsibilities of milking it every morning and evening, a job often delegated to youngsters. The photograph was taken in 1941. (Courtesy of the Garnsey family.)

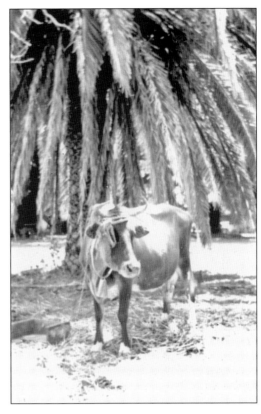

A proud farmer, Murray Lamb shows some of his huge sweet potatoes. He worked with his father on the Lamb ranch and raised Muscat grapes. He married when he was about 65 years old and did not have any children.

45

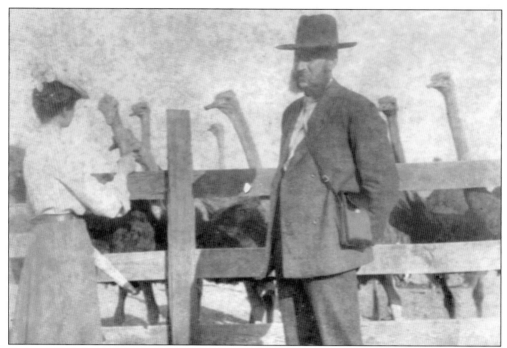

Around 1912, Lou and John Mack posed at the Fallbrook Ostrich Farm, where they worked, along Mission Road, south of Heller's Bend. It was the first ostrich farm in the United States when it started in 1883. At one time, feathers sold for $350 per pound. In 1914, with the increasing popularity of open-air touring cars, sales of the delicate plume dropped in favor of sturdier hat decorations.

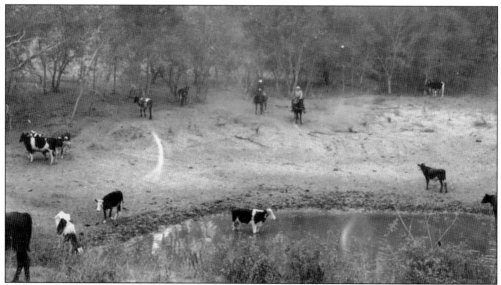

This early 1900s photograph of free-range cattle in DeLuz depicts how important water is to farming. In 1924, Jerome O'Neill, who was managing the Santa Margarita Rancho downstream from the DeLuz Canyon, became concerned about the amount of water the Vail Ranch used from the Temecula and Murrieta Creeks upstream. After a lengthy lawsuit, the Vails built a dam to satisfy their water requirements. (Courtesy of the Garnsey family.)

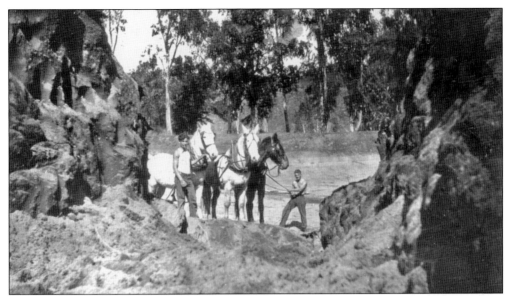

In 1949, Felix Garnsey, right, and an unidentified man worked with the team of horses and a fresno blade to build the reservoir at the Garnsey Ranch; it held 42 acres of water. The family sold 135 acres of land up DeLuz Canyon from their home in 1976, which included both Frog Pond, created by the reservoir, and Tadpole Pond. Both ponds were destroyed in floods around 1979. (Courtesy of the Garnsey family.)

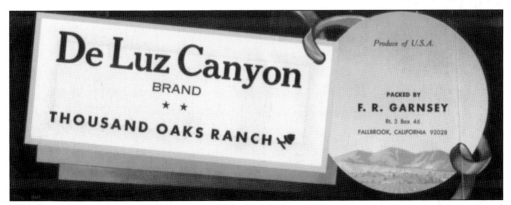

The fertile soil of Garnsey's Thousand Oaks Ranch has produced a wide variety of agricultural products through the years. This is a 1947 box label for their peaches, a prime crop for the Garnseys from the mid-1940s to 1960. (Courtesy of the Garnsey family.)

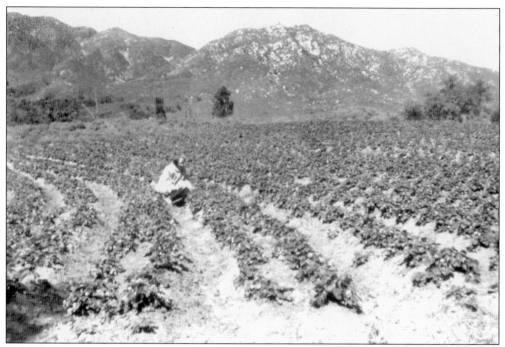

Teddy Garnsey, a city girl, moved to her new husband's DeLuz ranch home in 1934. Felix plowed his fields using horses, and Teddy cooked in the fireplace that heated their adobe home. She remarked that fires and floods kept things interesting at times. In 1957, the Garnseys planted Citrus Hill and the Flat with strawberries. Rocky Peak is visible in the background. (Courtesy of the Garnsey family.)

This photograph shows the original house at the Garnsey Ranch, built in the 1880s, on the left. The post office is the small building in front of it. The shed on the right, built in 1907, was used to store Muscat raisins that were grown by the Garnseys. When the old house was torn down, the Garnseys built a new home around the shed, making it the living room. (Courtesy of the Garnsey family.)

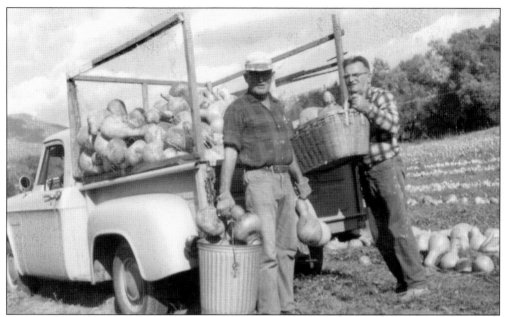

This photograph shows the Garnsey family packing gourds into the back of a pickup truck during one of their first harvests. Initially, their gourds were sold in Hawaii to make hanging planters. The Wellburn Gourd Farm, the largest gourd supplier in the United States, now leases 110 acres from the Garnseys. They produce 375,000 gourds a year and ship them all over the United States. (Courtesy of the Garnsey family.)

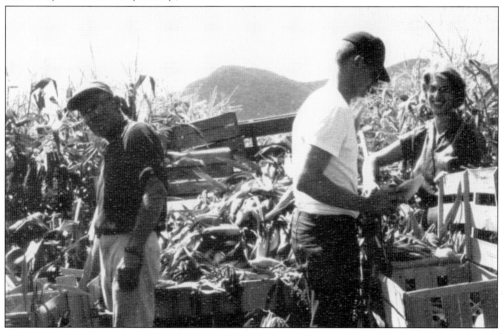

Here the Garnseys are harvesting corn. They grew various crops through the years, including grapes, strawberries, peaches, gourds, black-eyed peas, and corn. They also raised bees and farmed grain. Their Muscat grapes were used for raisins, table grapes, juice, and wine. (Courtesy of the Garnsey family.)

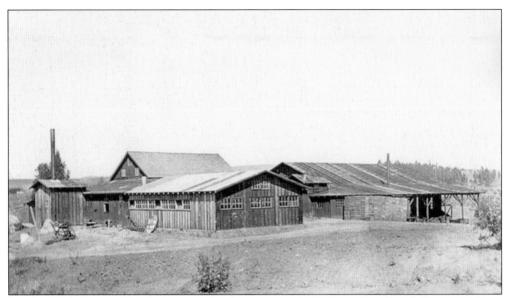

Workers at the Pratt Olive Plant on South Alturas Street made olive oil and bottled it for shipping. In 1895, the Loma Ranch on South Alturas Street had a large olive press and bottling plant, where fresh olives were brought in large crates by horse and wagon. They produced about 15,000 gallons of high-grade olive oil each year, until 1919. (Courtesy of FHS.)

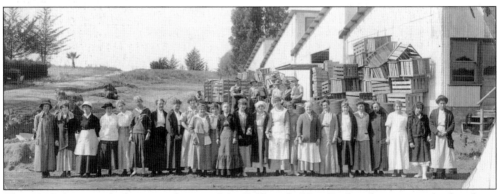

This 1916 photograph shows employees of the Fallbrook Olive Packinghouse outside the plant, where 215 West Fallbrook Street is today. Eric Hindorff is the tallest man in the back row, in front of the crates. No one else is identified. Olives were cured in big vats, first in a weak lye solution to remove bitterness and then canned in salt water. (Courtesy of FHS.)

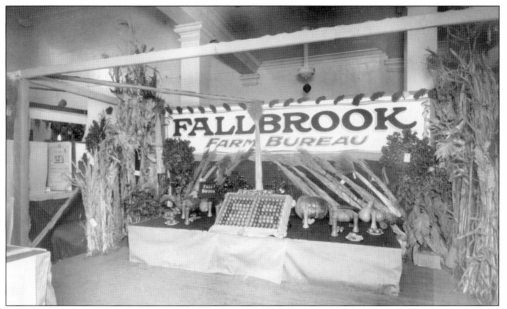

This is a Fallbrook Farm Bureau display at the San Diego County Fair during the 1920s. The Farm Bureau was very active in Fallbrook during that era. Annie Lamb and Mary Gird Peters helped to set up this display.

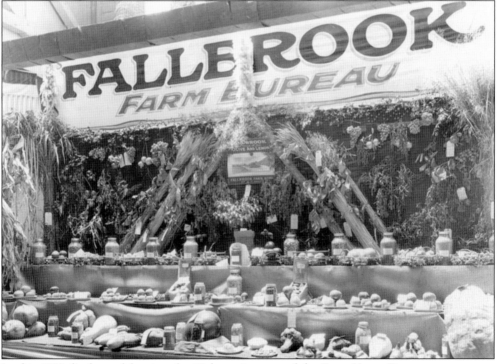

In this 1938 display, celebrating the 20th anniversary of the Farm Home Department, women exhibited three varieties each of dried vegetables and dried fruit and seven varieties each of candied fruit and canned and preserved fruit at a community fair. Mary Gird Peters supervised the Farm Bureau Center for a number of years.

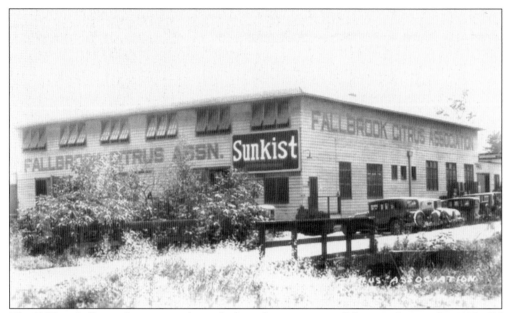

The Fallbrook Citrus Association formed when there were just 176 acres of citrus; by 1919, 436 acres were planted. This is the packinghouse where Sunkist produce was prepared for shipping. From 1915 to 1916, citrus growers earned a total of $16,000. In 1918 and 1919, they earned $56,000. (Courtesy of Pomona Public Library.)

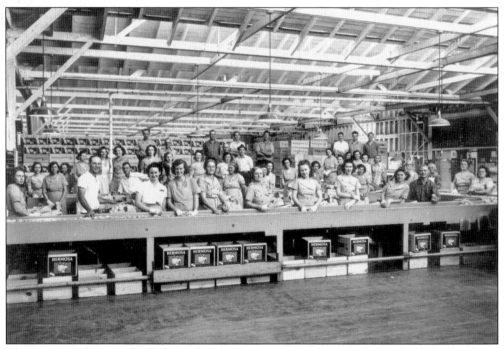

This is a 1940 photograph of "the packinghouse gang," a predominantly female work crew doing seasonal work to supplement their family incomes. The citrus fruit was sorted by size and packed into boxes, like those under the countertop. Trains shipped the fruit from the packinghouse across the United States. (Courtesy of FHS.)

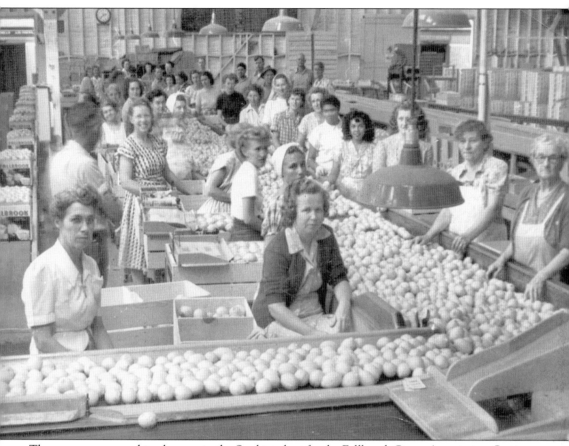

These women are packing lemons in the Sunkist plant for the Fallbrook Citrus Association. Some women worked up to 30 years doing this seasonal work and became very proficient in judging the size and quality of the fruit. Each lemon was wrapped in special paper before packing it into rows in the boxes. Each box was known as a number, "20 by 27" for example, indicating the size of the fruit, how many lemons were in each row, and the number of rows. (Courtesy of FHS.)

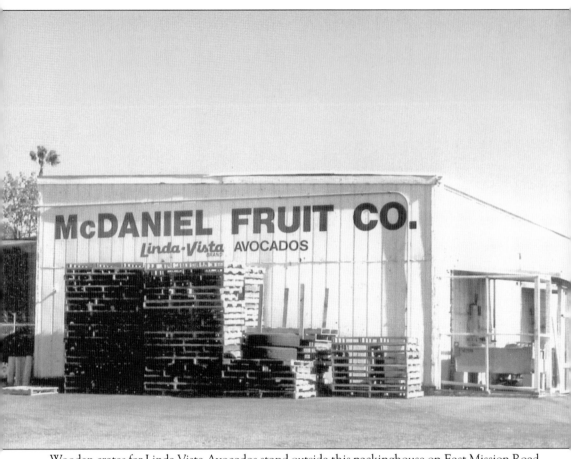

Wooden crates for Linda-Vista Avocados stand outside this packinghouse on East Mission Road. From there, semitrucks carry the avocados to shipping outlets throughout the Western United States. From 1982 through 1985, Fallbrook had 88,000 acres of avocados, but today there are 55,000 to 65,000. (Photograph by author.)

Four

PIONEER FAMILIES

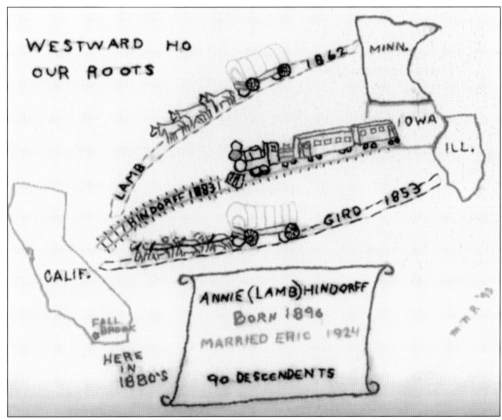

This piece, embroidered by Margaret Hindorff Ray, depicts three pioneer families of Fallbrook, their states of origin, and their modes of transportation to the West. The Lamb, Gird, and Hindorff families have each left their traces in the history of Fallbrook. As one of their descendants, Margaret Hindorff Ray has worked with the Fallbrook Historical Society, the Reche Community Club, and the authors of this book to preserve memories of the early days in Fallbrook. The community is fortunate to have access to Margaret's wonderful photograph collection. Her family photographs give a glimpse into the experiences of all the pioneer families, even those who did not chronicle their stories in photographs and documents, like those shared in this book.

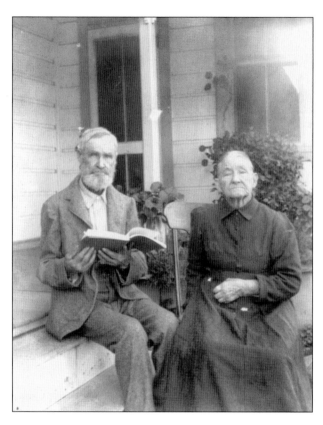

Henry Harrison Gird and his wife, Martha Stites Lewis Gird, sit on the porch of their home in 1902. They purchased 4,990 acres of Rancho Montserate for a dollar an acre in 1876. The Alvarado family received a grant of 13,314 acres from Mexican governor Pio Pico but was eager to sell it after several family members died from smallpox and other tragedies while living there.

Pictured is the Henry Gird Ranch in 1913. Henry and Martha Gird started from Illinois in a covered wagon in 1853. They first settled in Placerville, California, but instead of mining gold there, Henry sold produce and beef to the miners. They came to Fallbrook when they heard that Rancho Montserate was for sale and spent the rest of their lives here, passing to eternity within weeks of each other in 1913.

This is how the Old Shepherd's Adobe, southwest of Live Oak Park, looked in 1912. It was old and abandoned in 1902. Pala Indians stayed in it when they came to harvest acorns and to earn money by cutting wood for local residents. In the 1920s, D. O. Lamb bought the adobe. The McEuen family lived in it from 1920 to 1950 and only recently sold it and the surrounding property. It is a residence today.

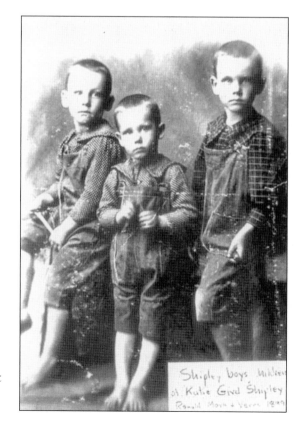

The barefoot Shipley boys posed for this photograph in 1899. They are, from left to right, Ronald, Mark, and Vern. Each was born in Fallbrook and attended Fallbrook schools until they graduated from high school. Vern stayed at the old home place, once part of the Gird Ranch, and raised turkeys for many years.

When William Gird built his ranch house in 1914, it was the first poured concrete home in San Diego County and replaced the original wood-frame house built in 1885. It was designed by Richard Requa, a prominent San Diego architect. The wood from the first house was eventually salvaged and used to build a home for Katherine Lamb McEuen in Yucca Valley. William raised purebred Devon cattle into the 1940s.

Lucy "Ellen" Gird Lamb was born to Henry and Martha Gird in Sutter County, California, in 1859 and lived to be 104 years old. A strawberry blonde tomboy, she graduated from Los Angeles High School in 1879. She and her sister Sally did trick riding on horseback. Lucy met her husband, James Orren Lamb, the son of her father's friend, when he did carpentry work for her father.

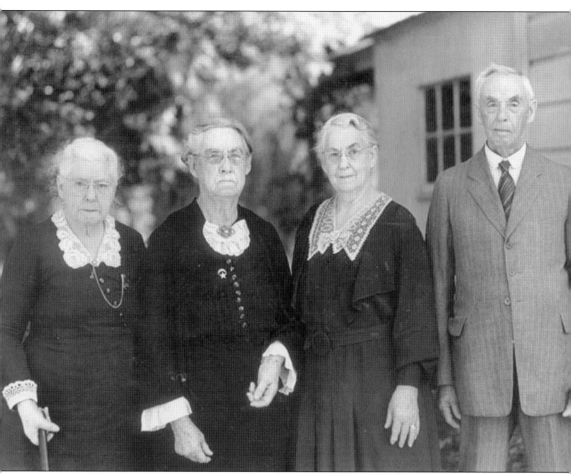

Pictured here in 1939 are, from left to right, Mary Lewis Gird Peters, Lucy Ellen Gird Lamb, Katie Gird Shipley, and William Gird, all children of Henry and Martha Gird. Mary was proud to tell how when she was born in 1853, the wagon train stopped in a miners' camp, and a miner loaned her mother his miners' cradle, used to wash gold, for the new baby to sleep in.

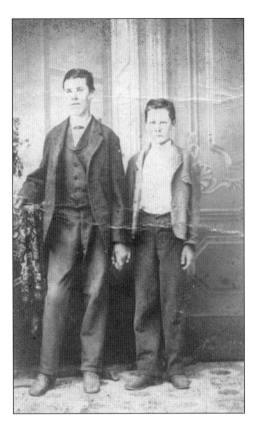

Jerome and Denver (D. O.), pictured in San Bernardino, were born to James Orren Lamb and Mary Jane Fillmore Lamb. In 1862, they journeyed from Minnesota to Oregon with miners in a wagon train on the Overland Trail. They suffered hardships and dangerous encounters with Native Americans before they arrived in San Bernardino, where James Orren (J. O.) had a dairy farm on Lytle Creek. The family came to Fallbrook in 1899.

This photograph was taken between 1871 and 1877, when J. O. rented and farmed land in Los Angeles. He moved to The Palms, where he farmed and served as deputy constable and road overseer for 12 years. A member of the International Order of Odd Fellows (IOOF) and a staunch Republican, he is buried in the Fallbrook Odd Fellows Cemetery.

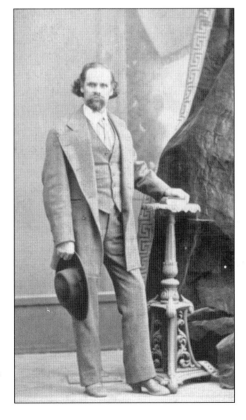

In his old age, J. O. Lamb, pictured sitting at the Naples Hotel, reflected on his life. His father died in an accident while working on the Erie Canal when J. O. was two years old, and J. O. and his brother Jerome Osmer lived with other people because their mother could not support them. He had very little schooling.

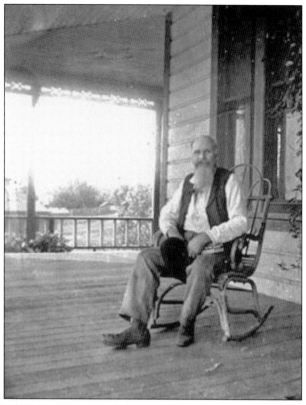

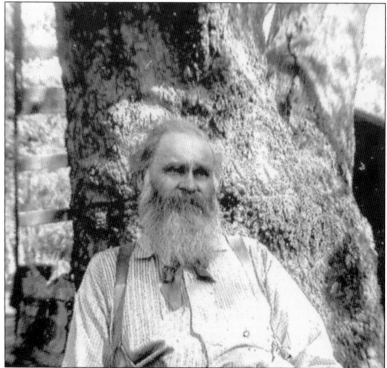

At the age of 14, J. O. Lamb ran away and became a cabin boy on a whaling ship from New Bedford, Massachusetts. After he became second mate, he sailed for seven years, visiting nearly every country on the globe. At one time, he was shipwrecked on a cannibal island. He said he would have been eaten, but the sailors who smelled of tobacco, like him, were released.

61

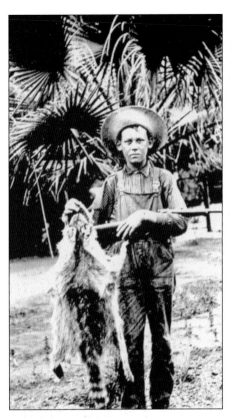

Pictured is Denver Orren Lamb Jr. His father, Denver Orren (D. O.) Lamb Sr., although born in Minnesota, was given his unusual first name because his father was in Colorado working on a Pikes Peak surveying crew when he was born. D. O., his brother Jerome, and sister Calista journeyed west with their parents. After settling in Fallbrook, D. O. built his parents a home across the creek from his own house.

This photograph was taken when D. O. Lamb campaigned to be on the San Diego County Board of Supervisors. He conceded the position to his opponent, Gerald Westfall, because of a discrepancy in the voting. D. O. was a strong and positive leader in the community and was an active member of the Masonic Lodge and the Odd Fellows Lodge. After his death, he was remembered for saving the oak trees of Reche Grove.

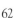

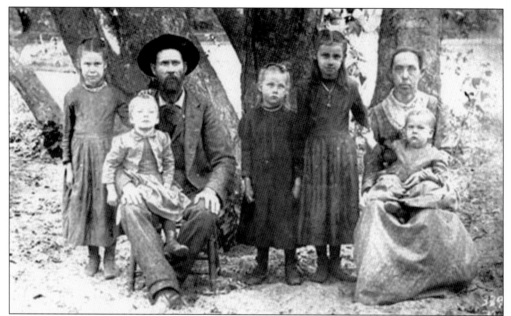

In this 1895 photograph taken on the Lamb property in Gird Valley are, from left to right, Kate, Murray, Denver Sr., Lucky, Nettie, Lucy Ellen, and John. All the children attended Fall Brook Grammar School, and four of them graduated from Fallbrook High School. Lucy and Denver Jr. went on to college. The photograph was taken by R. H. Gardiner, a photographer from Whittier, California.

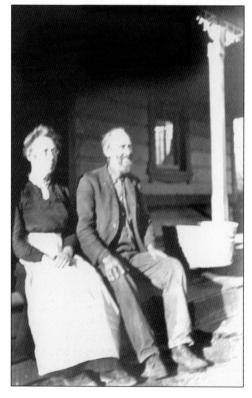

D. O. and his wife, Lucy, served as leaders in the Farm Bureau. He was a dry farmer with only two years of schooling, but he was remembered as an avid reader and as a man of high intelligence. He served 29 years as a trustee for the Fallbrook School and Fallbrook Union High School. After the Fallbrook School burned in 1896, classes met in D. O. and Lucy's home until the new school was built.

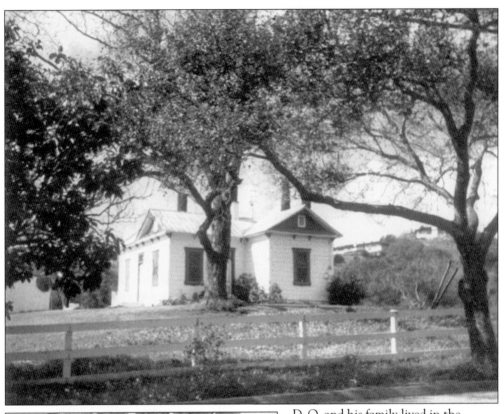

D. O. and his family lived in the barn while their home was under construction. It is similar to the one he built for Henry Gird (seen on page 58). It is now a bed and breakfast on the 2100 block of Gird Road. This photograph was taken in 1985.

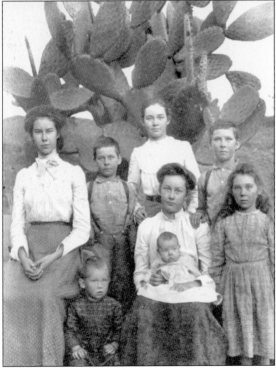

The Lamb children pose by a prickly pear cactus on their property in this c. 1901 photograph. Pictured are, from left to right, (first row) Denver Jr.; Edna, holding baby Lucy; and redheaded Annie; (second row) Kate, John, Nettie, and Murray, whose sweet potatoes are featured on page 45.

This photograph shows the Lamb children growing up. Pictured at the Lamb property on Gird Road are, from left to right, (first row) Edna and Lucy; (second row) Denver Jr., Nettie, and Annie; (third row) Kate, John, and Murray.

This photograph of the D. O. Lamb Ranch, creek bottom, and pond was taken in May 1912. The Lambs raised beans, barley, and oats to sell, and they enjoyed homegrown apples, pears, plums, and grapes.

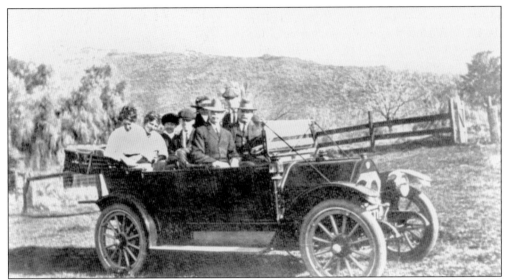

Pictured here from left to right, the passengers in the Franklin automobile are Nina Allen Gird, Katie Gird Peters, Ellen Gird Lamb, D. O. Lamb, Mary Gird Peters, William Gird, Herbert Peters, and Jefferson Shipley. The photograph was taken in 1914 at the Shipley Ranch on Gird Road, once part of the Gird Ranch.

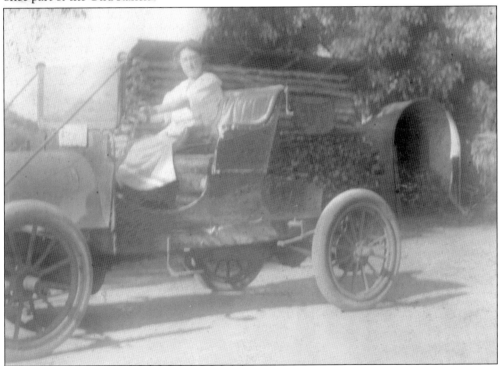

John Lamb taught his sister Annie to drive before he went into the army to serve in World War I. She was the only one who knew how to drive the 1906 Franklin while John was away. Annie had to crank the car by hand to start it in that era before batteries were used to power starters. The radiator was air cooled, not water cooled. Fenders were removed to give it the look of a speedster.

Annie Lamb stands by D. O. Lamb's windmill in the 1920s, holding the doll she made from a china head and recycled arms and legs. Note her dark stockings, which were worn before nylon hosiery was invented.

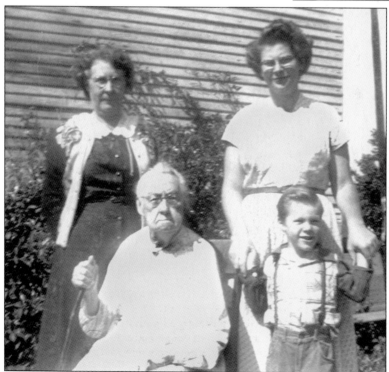

Pictured from left to right Annie Lamb Hindorff, Lucy Gird Lamb, Margaret Hindorff Ray, and Eric Ray celebrate Lucy's 96th birthday in 1955 in this four-generational photograph; Annie was Lucy's daughter, Margaret was Annie's daughter, and Eric is Margaret's son. They posed in front of Edna Lamb Graffin's tank house, which sat over the well. A gasoline engine pumped water into the tank.

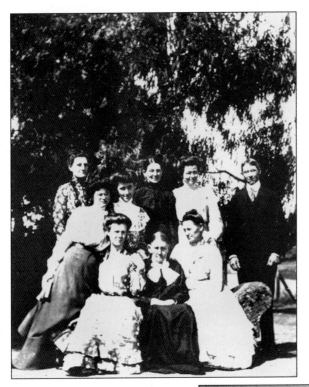

This *c.* 1910 photograph, taken in the front yard at Leanore Vaughn Hindorff's home in Fallbrook, features, from left to right, (first row) Dora Hindorff, "Grandma" Ann Vaughn, and Lucy Mack; (second row) Martha Newcomb, Mabel Hindorff, Edith Newcomb, Leanore Hindorff, Leora Hindorff, and a friend of Leora's who is not identified.

This is Leanore Vaughn Hindorff in 1938, just months before she died. She and her husband, Gus, a Swedish immigrant, left Iowa on a 10-day immigrant train in 1883. In Sacramento, they boarded a Southern Pacific train to Temecula. They knew of the virtues of Southern California from George Hind, who had also lived in Lewis, Iowa, before moving to Temecula. When Gus died in 1889, Leanore completed their homestead requirements of improving the land and residing on their property for five years.

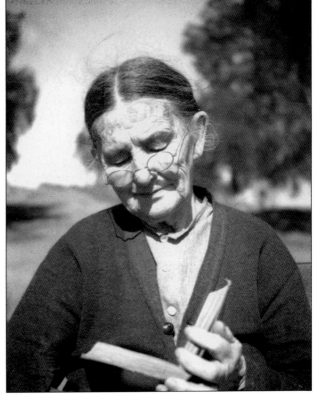

This home, built by Eric Hindorff in 1911, stands on Gird Road and is still owned by the family. Margaret Hindorff Ray says, "For a longtime, there was no skirting between the floor and the ground, so the wind blew in, and animals slept under the house. Sometimes even the chickens slept under the house. We eventually got some used lumber and enclosed the space under the house, and it was warmer inside."

This is the backside of an adobe Eric Hindorff constructed for storage in the 1920s, using a Swedish design for the roofline and eaves. His second wife, Annie Lamb Hindorff, planted the organ-pipe cactus on the east side. She also planted the golden rod and had a large cactus collection, gathered from the deserts in the Southwest. Eric kept his Native American relics in the adobe. The photograph was taken around 1950.

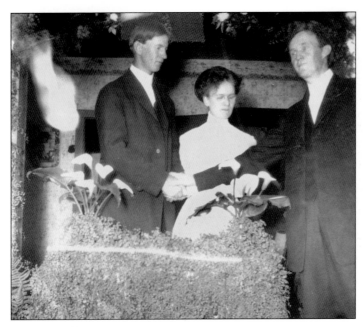

Eric Charles Hindorff married Pearl Bell at the Fallbrook Methodist Church in 1911, with Reverend Bear officiating. After their marriage, neighbors gathered tin cans and cowbells to make noise outside, while a modest reception took place at the home of the bride's parents. The noisemakers giving the "shiveree," as it was called, included Lee Jennings, Jim Westfall, and J. A. Martin. They stopped when they were given cake and cigars.

Eric and Pearl Hindorff settled in on Reche Road near their apiary, where the Atkins Nursery is located now. After a fire destroyed their home and all of his bees, they moved into a tent on property Eric owned on Gird Road. Eric then built a house made of used lumber (pictured on page 68). They had three young children when Pearl died in 1924. They are, from left to right, Jerry, Dick, and Velma.

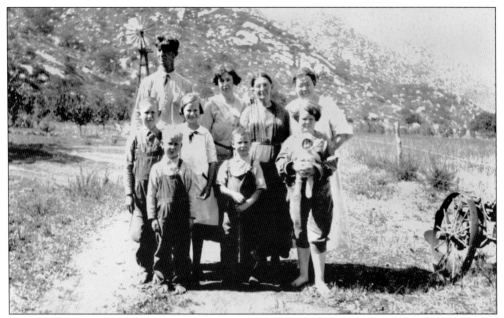

In 1917, the Hindorffs stand on the road to the ranch Leanore homesteaded in 1889. It was located about where the off-ramp from the truck scale joins southbound Interstate 15 today. Pictured are, from left to right, (first row) Jerald, Richard, and Velma Hindorff, Edward Stubblefield, and Winifred Pitman; (second row) Eric Hindorff, Dora Stubblefield, Leanore Hindorff, and Leora Langford Pitman.

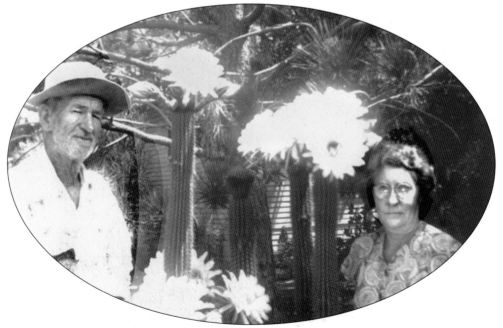

Eric Hindorff knew Annie Lamb from the local dances where he played his violin. After his first wife, Pearl, died, he asked Annie if she would like to learn to play chords on the piano to accompany him on the violin. They married a few months later and brought three more children into the Hindorff family. They made beautiful music together the rest of their lives.

71

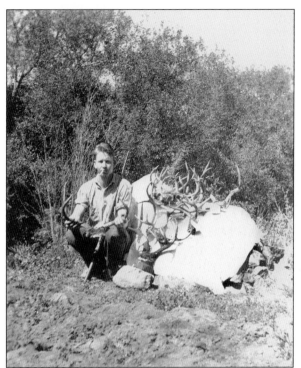

Dick Hindorff is pictured in 1940 with deer antlers he got from hunting in and near Fallbrook. Dick learned how to hunt from his father, Eric. Dick served in the Signal Corps from 1941 to 1945 and then was in a chemical warfare unit. He later spent 30 years working for Pacific Telephone in Escondido.

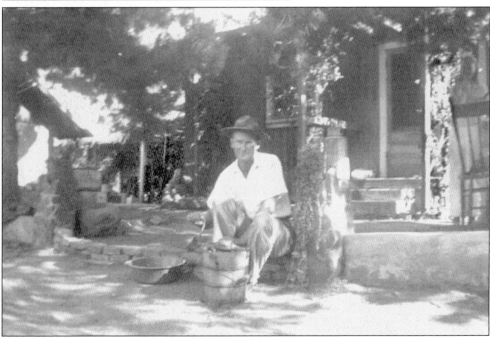

When Jerry Hindorff was on leave from the U.S. Army in February 1942, he wanted to make ice cream, and he is pictured cranking the ice-cream maker on the steps of his parents' home. During childhood, he and his older sister Velma would sometimes take the family springboard wagon to the top of the hill, without any horses, and coast down with just a rope tied to the axles to steer it.

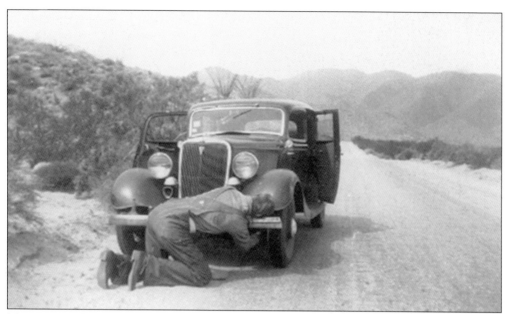

Margaret Hindorff Ray went with her parents to the Borrego Desert in 1946, while her husband, Otto, was in Japan with the U.S. Marine Corps. Her father, Eric, was prepared with a jack and spare tire to fix the inevitable flat from the rough roads. Around 1918, Eric bought a 1911 Studebaker with right-hand drive and an emergency brake outside on the right. It was magneto run and had to be hand cranked.

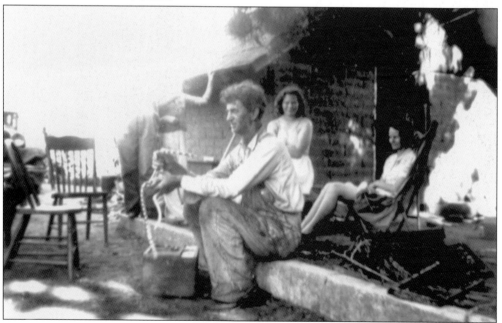

Eric Hindorff caught live rattlesnakes and sold them in Los Angeles for food and also enjoyed showing them. During World War II, he sold rattlesnakes to the government to make antivenom serum. He also supplied the San Diego Zoo and other agencies with snakes and reptiles for zoological research. Pictured behind Eric in this 1940s photograph are, from left to right, his wife, Annie, and daughters Laura, Margaret, and Velma.

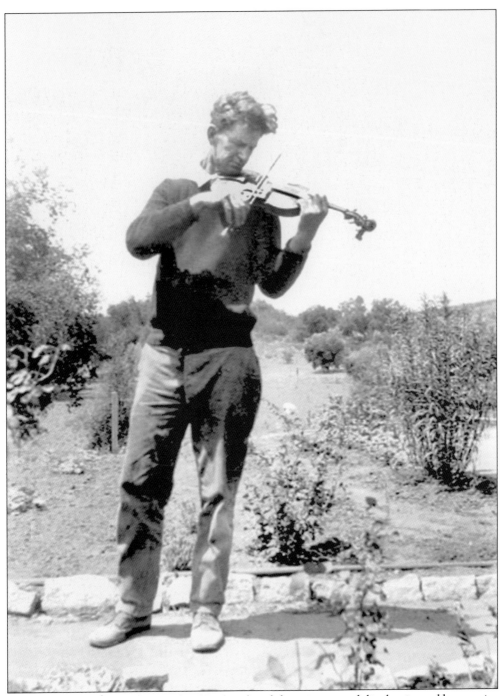

Eric learned to play his father's violin. He also played the guitar, mandolin, banjo, and harmonica and played for square dances, even after he lost his little finger from a rattlesnake bite. Most of Eric's children played musical instruments, and several of his grandchildren and great-grandchildren are good musicians, too.

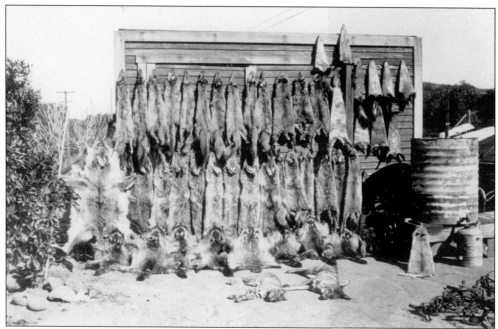

These are some of the furs Eric trapped for market. Once, someone wanted to send Eric a letter but could not remember his name and so addressed it "To a Tall, Wolf Trapper, Bee Inspector and Snake Catcher, Fallbrook, California." The mailman, Henry Ellis, knew exactly where to deliver the letter.

When Eric trapped for the U.S. Fish and Wildlife Service in San Diego, Riverside, and Imperial Counties, he needed to prove his productivity in order to get paid. This photograph shows Eric's coyote scalps drying on the side of a house. Times were hard, and people did what they could to make a living. Eric, like many Fallbrook pioneers, survived the hardships with courage.

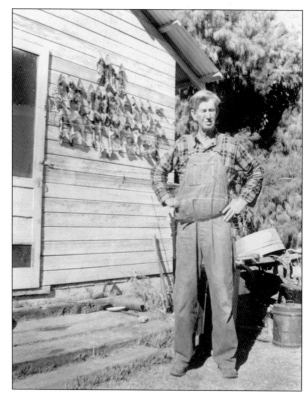

DeLuz was a village first settled in the mid-1800s by an Englishman named Luce. Some speculate his name was changed to the Spanish name "Luz," which means "light." Others say the settlement was named for a shepherd called Luz, who grazed his sheep in the valley before the Europeans arrived. (Courtesy of the Garnsey family.)

Frank Day and his horse "Wanda" delivered mail in DeLuz for many years during the early 1900s. They brought the mail from Fallbrook, often picking up groceries for families, too. He planted a palm tree at a spring located halfway to town so he would have a shaded rest stop. He was also a blacksmith. Ed Myers and Charles Wilmot helped him thresh his grain. (Courtesy of the Garnsey family.)

Postal service to DeLuz started in 1882; it was left at a big oak tree near DeLuz Creek, and people would go there to pick it up. During the early 1890s, the W. W. Wilmot adobe home served as a post office. Later the Reagan family hosted mail service in their two-story hotel, before 1914 when Louie Garnsey built a post office in his yard. The building pictured was in use from 1938 to 1955. (Courtesy of the Garnsey family.)

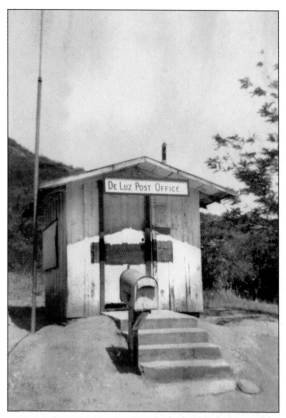

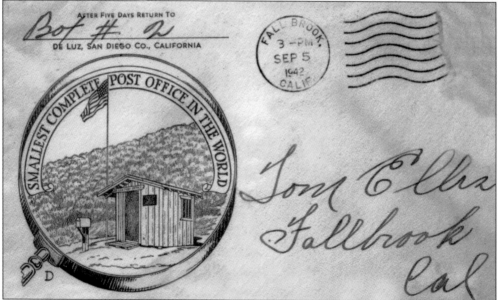

DeLuz's "smallest complete post office in the world" was honored on this envelope. The letter was written to Tom Ellis, a livestock dealer, who lived in Fallbrook. A school in Fallbrook is named after his wife, Maie Ellis, who was a teacher and principal, and the present-day Fallbrook Union High School is on their former ranch land. (Courtesy of the Garnsey family.)

Visitors pose near rocks in the DeLuz Canyon. Rocky Peak, Tom Casey Peak, and the foothills of the Santa Ana Mountains surround the community of DeLuz, northwest of Fallbrook, and the secluded area can only be reached by narrow, curving roads. (Courtesy of the Garnsey family.)

Mrs. Herron; Sonny, whose last name has been forgotten; and Stephen Garnsey climb rocks along DeLuz Creek in 1942. The Garnsey Ranch is now owned by Stephen, the fourth generation in his family to hold its title. His great-grandfather, James Garnsey, built an adobe house along Cottonwood Creek. He kept bees and shipped oak wood to Santa Ana where it was made into charcoal to use in the kilns at his brick factory. (Courtesy of the Garnsey family.)

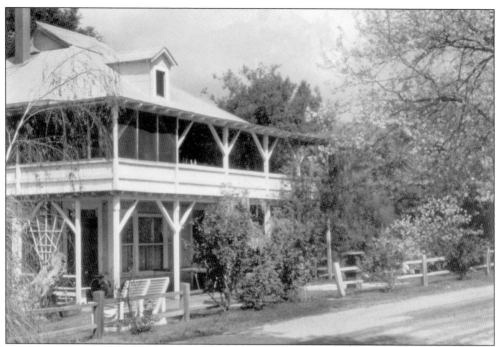

The DeLuz Judson Mineral Springs brought tourists to the area between 1880 and 1910, and the California Southern Railway built a station in DeLuz to accommodate the visitors of the 80- to 90-degree springs. They would take a five-mile buggy ride from the station to the health resort started by Lemon Judson, a Vermont native, seeking cures for maladies, including rheumatism, neuralgia, and deafness. (Courtesy of the Garnsey family.)

Felix, Ruth, and Harry Garnsey play with bark from a eucalyptus tree in the 1920s. These siblings descended from the Days and Garnseys who arrived in DeLuz in 1880, each buying 160 acres of land. The children attended DeLuz School through the eighth grade, and then they stayed with an aunt in Santa Ana to attend high school. The family did not get electricity until 1947, and the dirt roads were rough. They hauled grain to the Murrieta elevator. (Courtesy of the Garnsey family.)

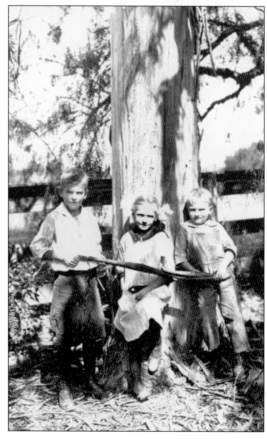

James Rainbow, a resident for whom the town of Rainbow was named, won the election for San Diego County Supervisor in 1890. When Riverside County was formed in 1893, his house was over the Riverside County line, while his barn remained in San Diego County. Not wanting to live in his barn to keep the required San Diego County residence, he resigned his position. (Courtesy of FHS.)

Charles Stubblefield and Dora Hindorff Stubblefield lived on the Rainbow property her mother homesteaded. In 1887, when James Rainbow and W. F. Gould purchased land from a Peter Larsen, the settlement was called Vallecitos. Because that name was already taken when they went to establish a post office, the town fathers debated on whether to call the town Larsen or Rainbow. Gould suggested they call it Rainbow because it had a pleasant ring to it.

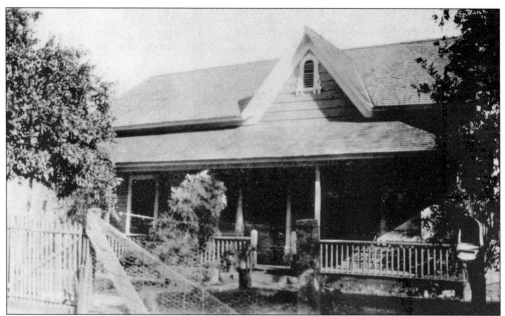

This is the Ludy home in Rainbow. The Ludys and the Kolbs were some of the early settlers. The Ludys lived where the Select Nursery is now, in the home pictured, which stood at the southeast corner of Rainbow Valley Boulevard and Fifth Street. The Ludys raised hay, grain, oranges, and stock animals. They recall that olive trees, black figs, and grapes were grown in their neighborhood. (Courtesy of John Ludy.)

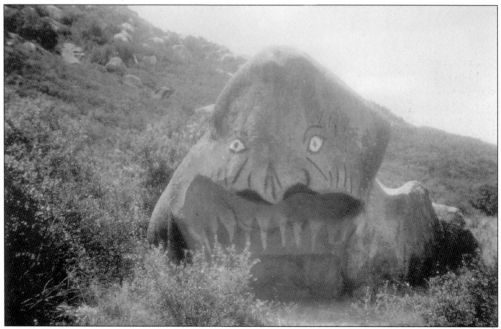

This boulder, personified as "Nahachish" in Luiseno legend, is located on Rainbow Canyon Road. In Luiseno myth, Nahachish was a giant chieftain who named villages in Southern California. It has captured the imagination of generations of people who have passed the lore on. No one can remember when the fierce face was painted on the stone.

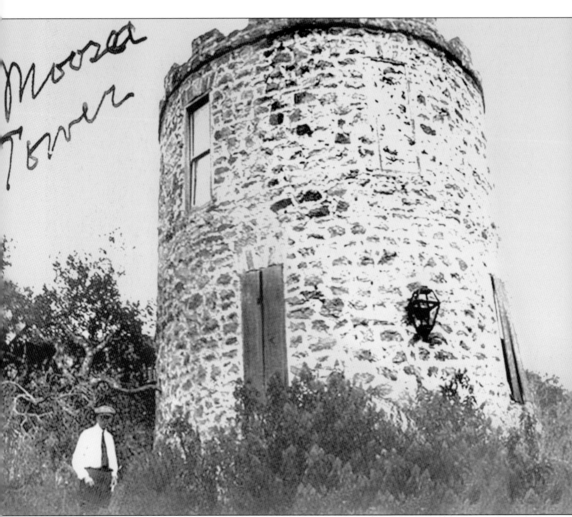

The 30-foot tower of Woreland Castle, constructed in 1893 by a Scottish stonemason for Isaac Jenkinson Frazee, is located near the present-day Circle R Ranch Golf Course, off Old Castle Road in Moosa Canyon. It is a replica of an ancient feudal castle in Scotland, the home of Frazee's ancestors. Frazee, an artist, writer, and poet, lived in the house he built around the tower until about 1927. From his office in the Woreland Castle turret, he had a commanding view of the surrounding countryside. Moosa Canyon is about 10 miles north of Escondido, near Interstate 15. The tower is still standing. The man in the photograph is presumed to be Frazee.

This *c.* 1920 photograph shows Annie, left, and Lucy Lamb visiting the Moosa Post Office. The sign reads, "Moosa, the smallest official post office in the United States, 33 by 43 inches, 12 miles from Escondido, Woreland, I. J. Frazee."

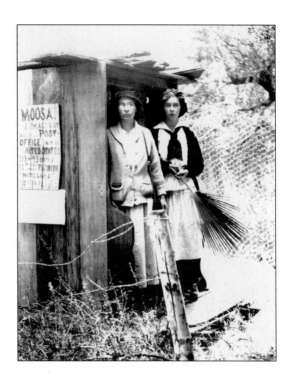

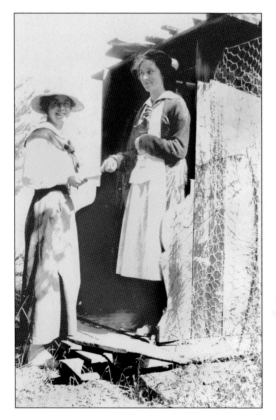

This is Frances Robinson and Lucy Lamb in another photograph taken on the same day. There was an old west gun battle in Moosa Canyon in 1887. Levi Stone, a homesteader in the canyon, took a trip back East. Upon his return, he found squatters living on his land who refused to leave. When a posse tried to evict them, eruption of gunfire ensued. As the smoke cleared, one of the posse and three of the squatters were dead.

This photograph, taken in Moosa Canyon around 1915, shows a hay rake and a windmill. Moosa's original name was Pamoosa, a Native American word meaning "long beard," because it looks like a bearded face is seen in the rock falls of Moosa Creek. When a post office was established, they changed the name to avoid confusion with Pomona in Los Angeles County.

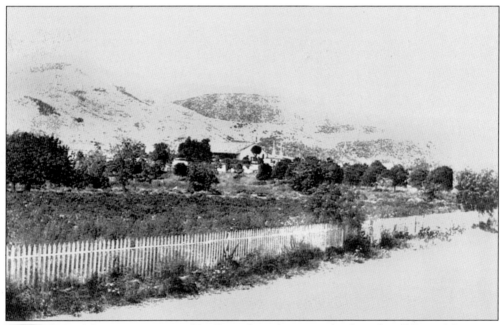

Rancho Santa Margarita was named by Spanish explorers on the feast day of Santa Margarita. It was later owned by Gov. Pio Pico and is now part of the Camp Pendleton Marine Base. The ranch house was built of adobe and from beams carried from Palomar Mountain. The rancho was one of the largest and richest in California.

Five

OTHER EARLY RESIDENTS

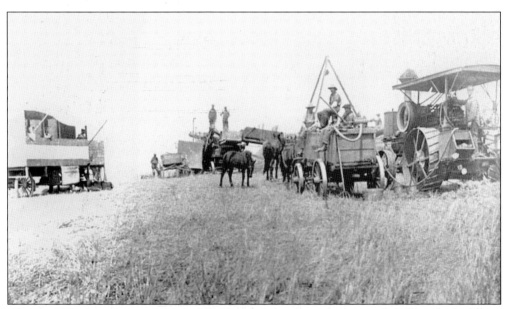

This is a 1908 threshing crew on the Ellis Ranch. Like all residents in early Fallbrook, the Ellises were farmers. Neighbors helped each other thresh their oats, barley, and other grain crops. Bill Ellis is one of the men; the others are not identified. (Courtesy of FHS.)

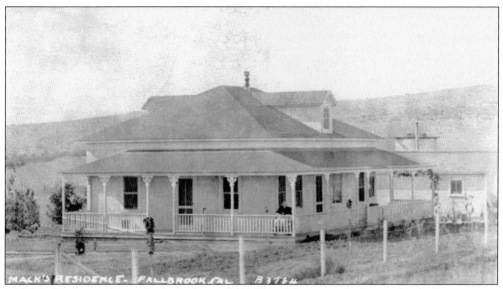

MACK'S RESIDENCE- FALLBROOK CAL | B 3784

John Mack, a horticulturist, built this beautiful Fallbrook home on the bottomland of his property on Morro Road shortly after 1900. Later he moved the house to the hillside, closer to the road and used the land for farming. The house is still used as a residence.

This 1899 photograph is of Harry E. White, the father of Frederick White. During the summertime, many residents, like the Whites, enjoyed the chicken dinners Eric and Pearl Hindorff served from their concession at Live Oak Park. Eric raised and dressed the chickens, and Pearl cooked. It was only $1.50 for half a chicken, mashed potatoes and gravy, vegetable salad, drink, and dessert. (Courtesy of FHS.)

This is a 1906 photograph of Harry White with his family. When Harry was growing up, most people had their own fruit trees and vegetable gardens. Some had olive trees and would take them to a Mr. Toffanelli, who ran a small olive oil plant east of Knoll Park. He would make oil for them, giving some oil back and keeping some to sell. (Courtesy of FHS.)

Pictured here is George White, a relative of Harry and Frederick White. During his lifetime, traffic went up Gird Road and through Live Oak Park to join Mission Road at Red Mountain Ranch, while the main highway through Fallbrook was being paved for the first time. Gas cost 25¢ a gallon, and kerosene cost 10¢ a gallon. (Courtesy of FHS.)

87

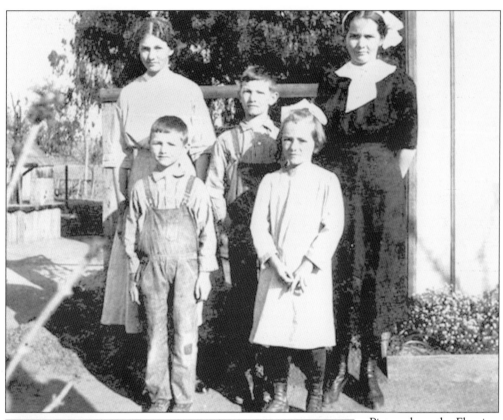

Pictured are the Fleming children, from left to right, (first row) James and Jessie; (second row) Grace, Walter, and Mabel. James and Jessie were the first twins born in Fallbrook. (Courtesy of FHS.)

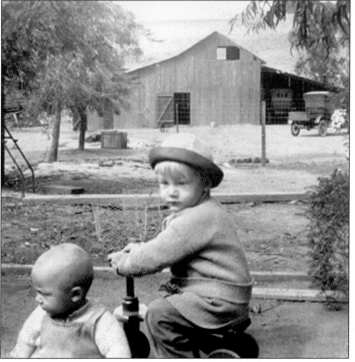

Robert Morse, left, and Eugene Fleming, right, play in front of Fred Stewart's barn and his 1920s Model T pickup truck in this 1924 photograph. A touring car of the same vintage is in the barn. (Courtesy of FHS.)

Pictured here is Ed Myers. During his lifetime, businesses on the west side of Main Street included C. E. Lamb's general store, Williams' Realty, and Harry Smelser's furniture store. On the east side of the street were Westfall's hardware, Hardy's drugstore, and Bailey's telephone office, which they ran out of their home. (Courtesy of FHS.)

Bill Fleshman wore this constable's badge for several years. One time, he called on Deputy Eric Hindorff to help him take into custody some undocumented aliens who were being smuggled in. The carload full of Chinese people was apprehended, and they offered no resistance or trouble.

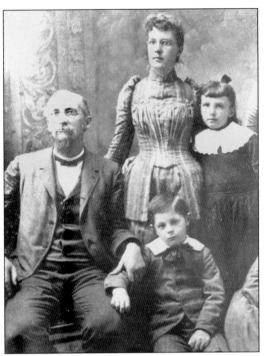

Rev. William Pittenger, a decorated Civil War veteran, and his family lived across the street from Fallbrook Methodist Episcopal Church, which he served from 1893 through 1896. He built a ranch house on his country property in 1895, land he bought from Millard Neff, who originally homesteaded the land. (Courtesy of Maie Ellis collection.)

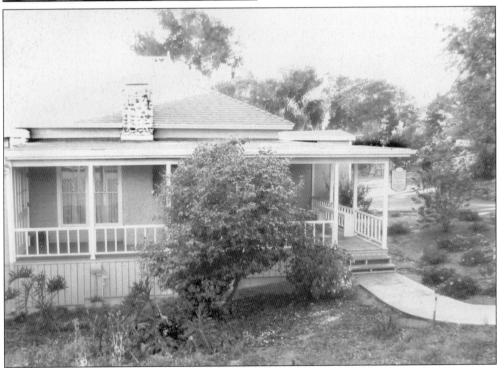

During World War II, Dr. B. C. Davies enclosed the porch of the historical Pittenger House and used it for a medical office. The Fallbrook Historical Society owns the house, which is part of the Fallbrook Museum, and offers docent tours of the historical home. It has been beautifully restored and refurbished with vintage furnishings. (Photograph by author.)

Henry Wilbur was an early pioneer and a trustee for the Fallbrook School, which burned down. He helped D. O. Lamb design the Reche School that is still standing. He and D. O. were friends and shared an interest in photography. Henry gave D. O. his first camera.

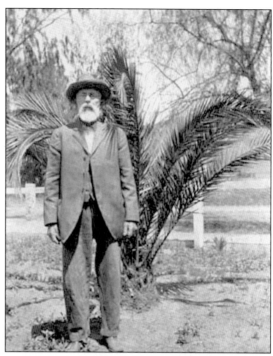

Henry Wilbur's family are, from left to right, May, Mrs. Wilbur, Frank, Rena, and Abby, who was the only family member who drove an automobile. Frank died after being struck by a car while walking along the road at night. Perhaps Henry took this photograph. All the Wilbur children graduated from high school the same year.

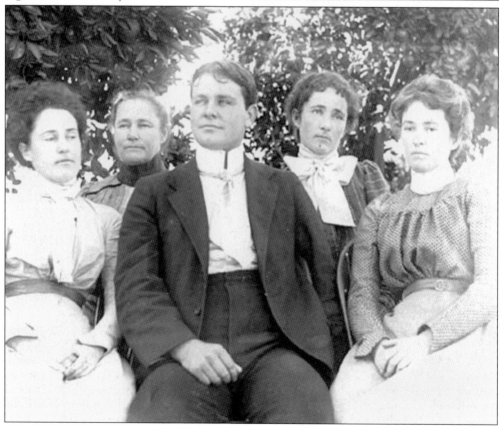

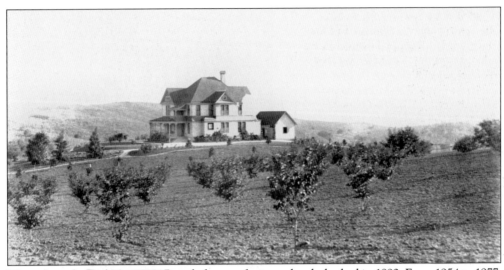

This is how the Red Mountain Ranch, known for its orchards, looked in 1892. From 1954 to 1977, Frank Capra, who produced *It's a Wonderful Life*, owned it. (Courtesy of FHS.)

"Grandpa" Watkins was a liveryman in early West Fallbrook. A photograph of his business on Alvarado Street is on page 21. (Courtesy of FHS.)

Charles J. Fox, a surveyor and civil engineer, came to California in 1869 and settled in San Diego because he liked the climate. He worked on the San Diego to Fort Yuma Turnpike. He had an apiary in Fallbrook, was the president of the Bee Keepers Association, helped incorporate the San Diego Society of Natural History, and was commissioner for most of the Mexican land grants. (Courtesy of FHS.)

Fred Lawrence Stewart posed in the Civil War uniform his father William Stewart once wore. Fred operated the feed store on Alvarado Street for many years and would help customers wheel bulk feed to their vehicles. His brother Bert was the foreman in charge of area roads. (Courtesy of FHS.)

In 1883, three men held a competition to see who could build the best and most attractive home for no more than $3,000. This is the two-story house Elmore Shipley built for the contest. It was on the south side of East Mission Road where the Berry-Bell and Hall Mortuary and Fallbrook Chamber of Commerce are today. The house was moved several times and still stands on Elder Street. (Courtesy of FHS.)

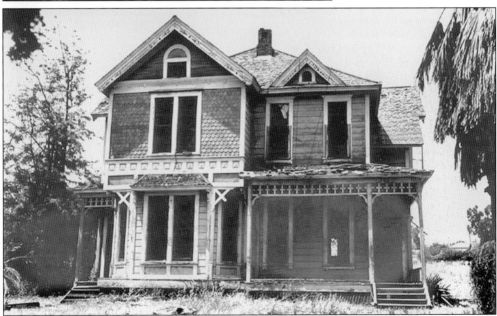

F. W. Bartlett built this two-story winning home from redwood with a shingle roof. A windowless adobe in the backyard kept food cool. The house was on the north side of the 300 block of East Mission Road, where a professional building is today. The third house in the competition, built by a Mr. Blackburn at the present location of the Fallbrook Street School, was never photographed before it burned. (Courtesy of FHS.)

John William Houston was born in 1869 in an adobe house in Temescal Canyon, near the Butterfield Stage Station. His son, Herbert Findlay Houston, was born in an adobe in Moosa Canyon. The family lived near Pala on Magee Road, and John farmed with Victor Magee. This photograph was taken in 1894. (Courtesy of FHS.)

The Peters boys, Frank, Ray, and Ross (from left to right), build a coaster out of lumber at the family's home in Willow Glen on the Santa Margarita River, while their farm animals look on. An old farm wagon is visible in the background. This early carpentry must have paid off, because Ray spent over 30 years making fruit boxes for the Fallbrook Citrus Association. (Courtesy of FHS.)

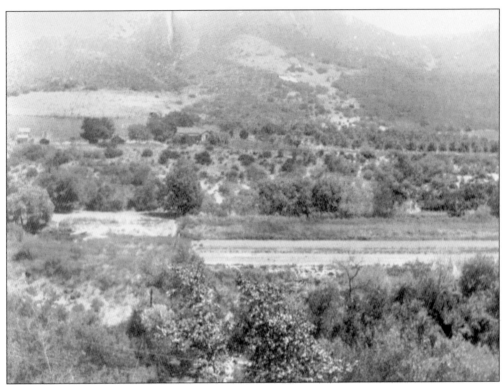

This early 1900s photograph shows the old Peters place in Willow Glen. The house sat on the bluff above two streams of the Santa Margarita River, and they had several outbuildings. The family kept bees and had an orchard.

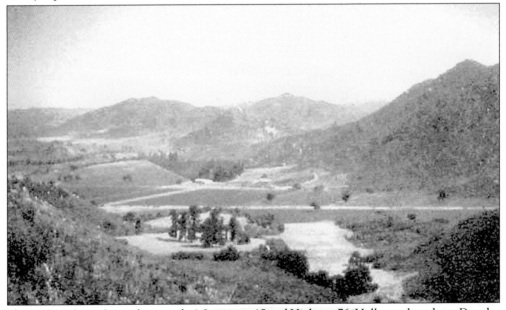

Shearer Ranch was located near today's Interstate 15 and Highway 76. Hollywood producer Douglas Shearer owned the valley during the 1940s; it was later owned by the Viejo Dairy. In recent years, a large subdivision of homes has filled the valley, and avocado trees grow on the slopes.

The oldest and youngest Vaughn daughters pose in a garden for this 1944 photograph. Amanda, born in 1849, was nearly 99 when she died. Alice lived from 1866 to 1953. She married Macedonia Machado, a Temecula merchant and quarry owner who donated granite for Live Oak Park structures.

Dr. A. Morgan delivered most of the babies born in Fallbrook. He was a typical country doctor who made house calls and delivered the babies at home. He was also a trustee for the high school for a number of years. His home and the medical office behind it are still on the north side of Alvarado Street at Mission Road. (Courtesy of FHS.)

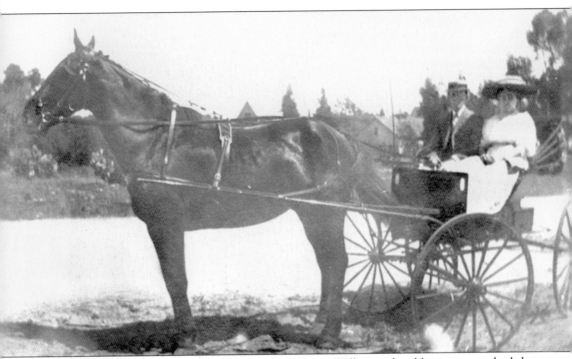

The McEuens owned a beautiful horse and runabout. William, a local businessman, had three daughters and three sons; however, two of his sons died at early ages. His wife, Katherine, was a school trustee and a secretary for the Fallbrook Public Utility District for many years.

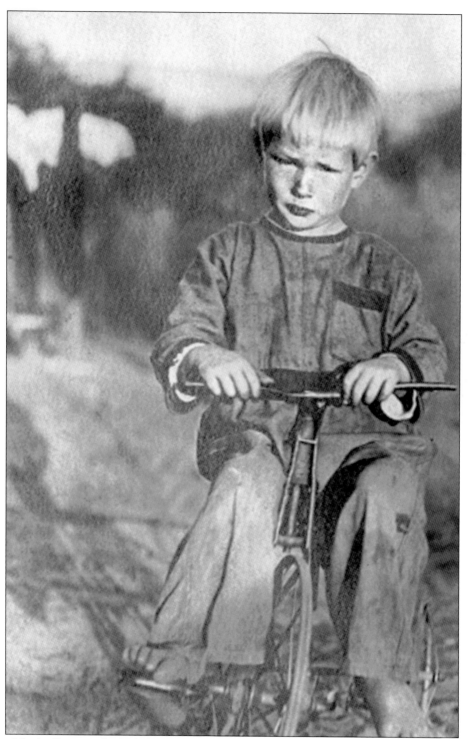

Jerry Hindorff enjoys the little bit of freedom afforded to him as he rode his tricycle around the Hindorff Ranch. His worn and stained coveralls protected him as he squinted against the morning sunlight, and his bare feet gripped the pedals. Jerry presently lives in Hemet, California.

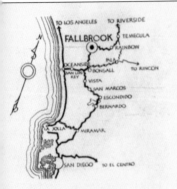

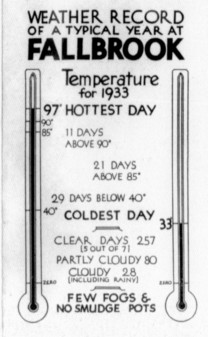

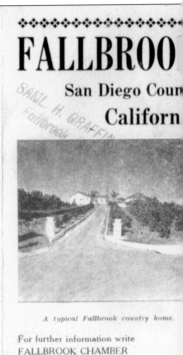

how to get to Fallbrook. Fallbrook is conveniently located so that residents have easy access to large cities.

Agriculture

For the easterner who seeks an income producing property along with a country home, Fallbrook is one of the best lemon, orange, and avocado producing districts in California. Soil and climate combine to make Fallbrook an ideal fruit producing area. Most of the growers market their fruit through cooperative marketing organizations.

Printed by The Fallbrook Enterprise

WEATHER RECORD OF A TYPICAL YEAR AT FALLBROOK

Temperature for 1933

97° HOTTEST DAY

90°

85° 11 DAYS ABOVE 90°

21 DAYS ABOVE 85°

29 DAYS BELOW 40°

40° COLDEST DAY 33

CLEAR DAYS 257 [5 OUT OF 7]

PARTLY CLOUDY 80

CLOUDY 28 [INCLUDING RAINY]

FEW FOGS & NO SMUDGE POTS

ZERO

Fallbrook's climate at a glance. Average rainfall over a period of 47 years is 17.99 inches.

FALLBROO

San Diego Coun

Californ

A typical Fallbrook country home.

For further information write
FALLBROOK CHAMBER
OF COMMERCE, Fallbrook, California.

This 1933 brochure, printed by the *Fallbrook Enterprise* newspaper for the Fallbrook Chamber of Commerce, extols the virtues of the temperate climate and rich soil. The photograph on the brochure exaggerates the size of a "typical" Fallbrook country home, enticing the reader to move to the area.

Six

CHURCHES AND SCHOOLS

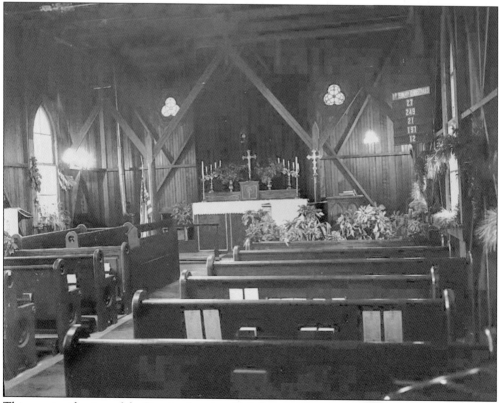

This rare inside view of the Baptist church, which has stood at the corner of Hawthorne and Pico Streets since 1887, shows it decorated for the marriage of Katie Gird and Jeff Shipley in 1890. The congregation was organized by Reverend Stenger in F. E. Bartlett's home in 1885. Charlotte Pratt Anthony played the piano and organ at the church for many years. (Courtesy of FHS.)

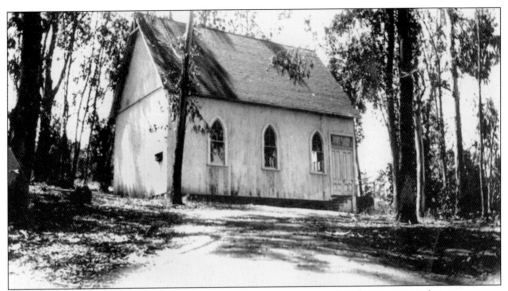

This is how the Fallbrook Episcopal Church looked in 1921, standing between eucalyptus trees on a hill two blocks from Main Street. Originally built as a mission church in 1891, the congregation moved into its present building at 434 Iowa Street in 1955. They are now constructing a new church on the northeast corner of Stage Coach Lane and Fallbrook Street.

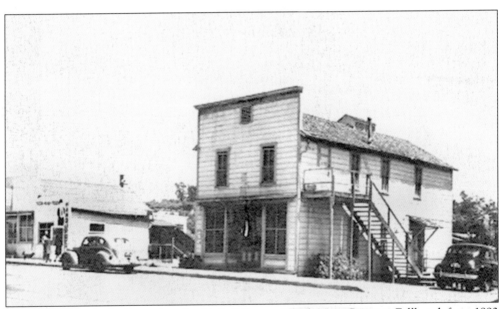

The Masonic Lodge held meetings in this building on North Main Street in Fallbrook from 1893 to 1948. Then they obtained a barracks building from Camp Pendleton and remodeled it at 427 North Hill Street, where they stayed until they designed a new building on Rocky Crest Drive at the south end of town. The building in this photograph was later used for a doctor's office and family residence. (Courtesy of FHS.)

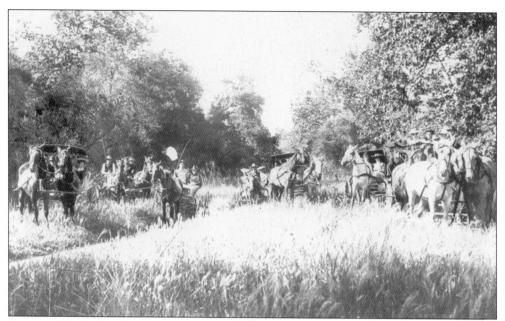

A group of high school students arrived at Reche Grove, north of the present-day Live Oak Park, for a picnic to celebrate the end of the school year in 1904. When the oak grove was considered for development, D. O. Lamb waged a political battle to save the trees. The grove is now the 27-acre Live Oak Park, thanks to D. O., the Houck estate, and the San Diego County Parks Department. (Courtesy of FHS.)

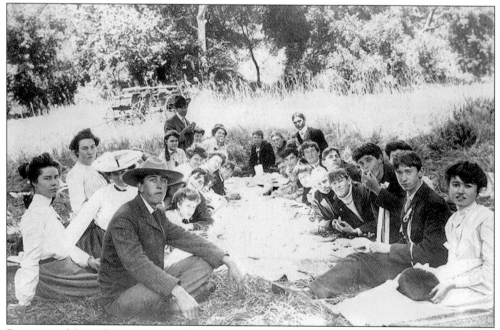

Dismounted from their carriages, these teenagers enjoyed their picnic at Reche Grove. Families represented in the photograph include Lamb, Pittenger, Pruett, and Van Velzer. Since its dedication as Live Oak Park in 1920, picnickers have enjoyed the concrete benches and tables. (Courtesy of FHS.)

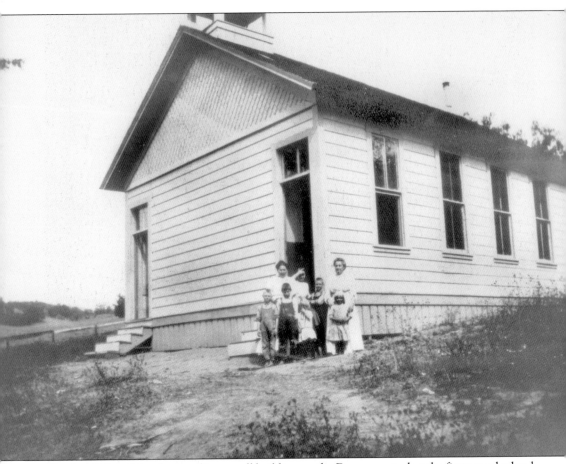

The first DeLuz School opened in a small building on the Day property, but the first actual school building, pictured here, was built on the Wilmot acreage, near the west fork of DeLuz Creek. The stone building that replaced it in 1927 is still standing. The school, closed since 1968, is now the DeLuz Ecology Center, and students are bussed there from Fallbrook and other districts to learn about nature. (Courtesy of the Garnsey family.)

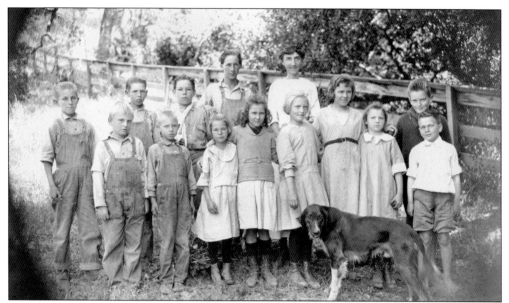

The students in Miss Ward's class at the old DeLuz School in 1922 are, from left to right, (first row) Carl Prahl, Harry Garnsey, William Dubel, Leona Prahl, Lois Bush, Ruth Garnsey, Winifred Bush, Levis Tiffany, Felix Garnsey, and Lee Tanner; (second row) John Dubel, L. Stoner, Bud Herron, and Miss Ward. The dog's name was Flash. (Courtesy of the Garnsey family.)

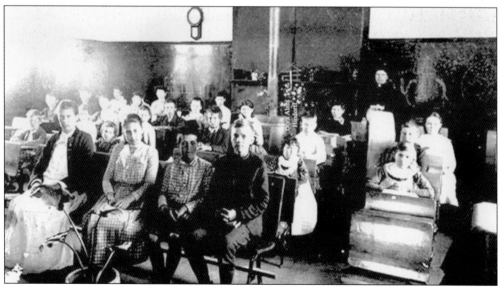

This rare photograph shows the interior of a one-room school in 1890. Taken inside the Vallecitos School in Rainbow, sober students held still while the camera took the photograph with a long exposure time. Two girls in the front row are wearing dresses made from flour sacks. Students here represented the Hindorff, Rice, and other families.

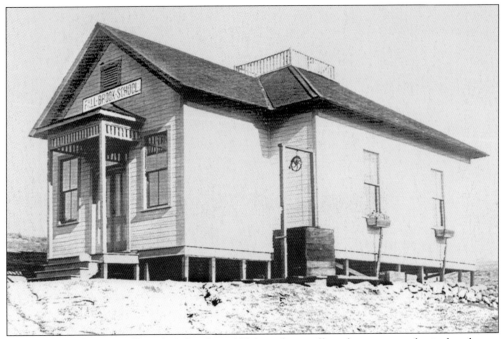

Pictured here is the Fallbrook School, *c.* 1896, with a well and ornamental window boxes planted with blooming flowers. Inside the entry, there was a transom above the door and library shelves on each side, separating the boys' and girls' cloakrooms. Beyond the entry, doors opened to the classroom. It is now known as the Reche School, a place to visit to learn about Fallbrook history.

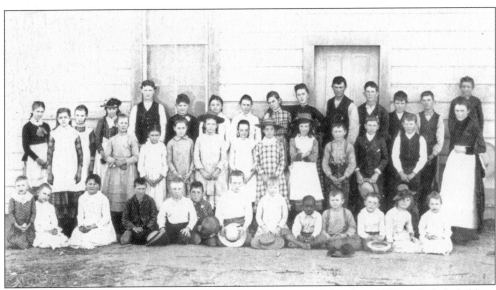

Laura Patterson's students at the West Fallbrook Grammar School in 1887 included children from the following families: Palmer, Tracy, Bush, Stewart, North, Tomlins, Waters, Eastman, Bell, Rice, Clark, Huff, Carpenter, and Roberts. (Courtesy of FHS.)

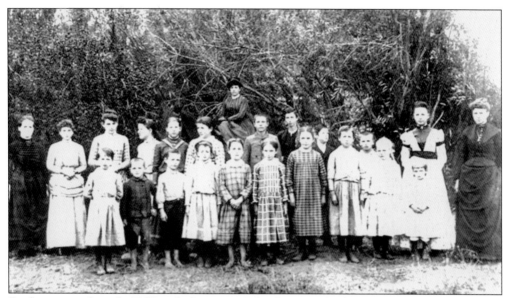

Students attending the Fallbrook Grammar School in 1889 had the surnames Peters, Sample, Gaston, Page, Wilbur, Frey, Burch, Freeman, King, Barnett, and McWalters. Fannie Fox is on the horse in back. She did library work in exchange for use of the school organ. The teacher, Miss Steinger, is in the back row at far right. (Courtesy of FHS.)

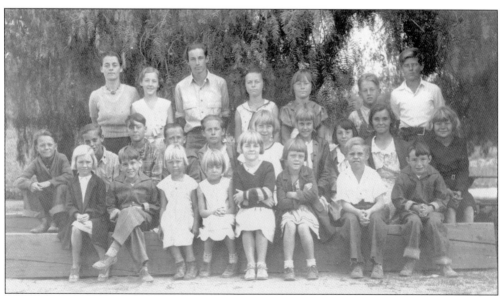

Children from the Brown, Graffin, Lamb, Fleming, Masheeco, Morse, Reynolds, McEuen, Wilson, Bullmer, and Hindorff families attended the Fallbrook School in 1932. Miss Friesen, at the top left, was their teacher.

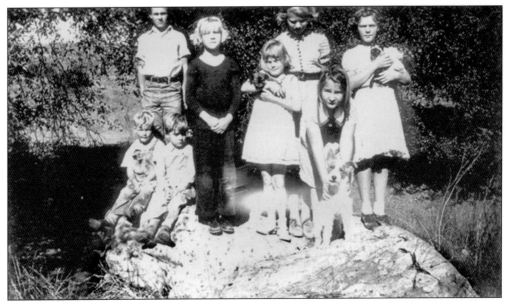

In 1938, Reche School students posed on the Native American grinding rock with their pets. Pictured are, from left to right, (first row, sitting) Riley Morse and Hamer Leighty; (second row) Richard Morse, Laura Hindorff, Billie Barbara Morse, Margaret Hindorff, Frances Hindorff, and Marion Morse.

The same pets and children sat for another photograph on the bedrock mortar at the Reche School. They always felt inspired to know that their schoolyard had once been a place where Native Americans camped.

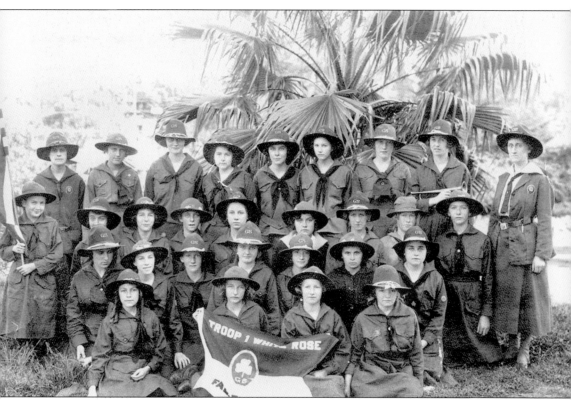

This Fallbrook Girl Scout troop was the first one formed west of the Rocky Mountains, and they called themselves "Troop 1, White Rose." Lucy Lamb, daughter of D. O. Lamb and Lucy Ellen Gird Lamb, is pictured in the back row, fourth from the left. None of the other Scouts are identified.

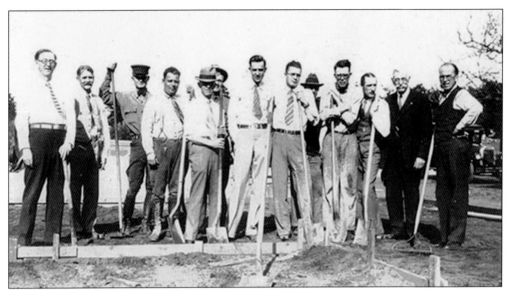

In the late 1920s, these men are breaking ground for the Scout Hut building. Included in the photograph are Bob Aaberg (third from the left); Dr. Morgan (second from the right); James Potter, the school superintendent (far right); and D. O. Lamb, president of the high school board of trustees (in the back wearing a dark hat). The others are not identified. (Courtesy of FHS.)

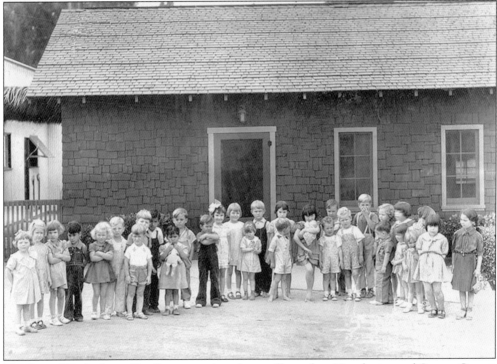

The Scout Hut, built as a Boy Scout meeting place, still stands at Hawthorne and Orange Streets on what used to be high school property. During the early 1940s, it was used as a nursery school for children whose parents worked at the citrus-packing plant. The building is now on the grounds of the Fallbrook Fire Department and is used for meetings.

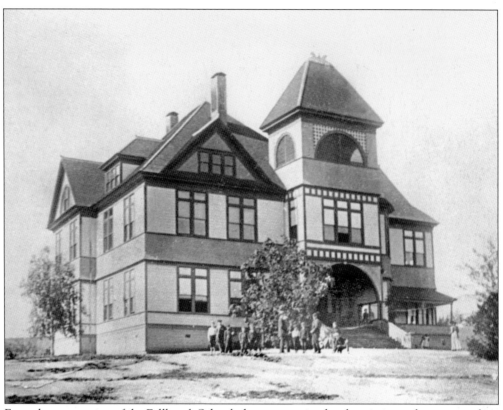

From the conception of the Fallbrook School, the community dug deep in its pockets to give their young people an excellent facility. When the Depression pinched funds, the Fallbrook Union High School received a federal grant to build a gymnasium, swimming pool, softball field, and model house for home economics. (Courtesy of FHS.)

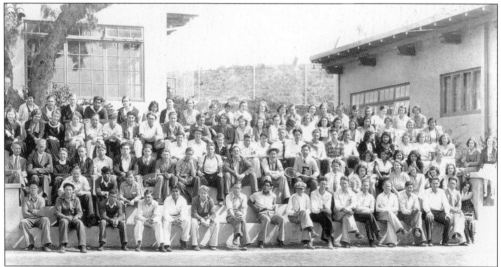

Pictured at the north end of the high school is the student body of Fallbrook High School in the 1930s. Barney Patton is near the middle wearing a letterman sweater and holding a tennis racket. He was active in student government and agriculture classes. (Courtesy of Barney Patton.)

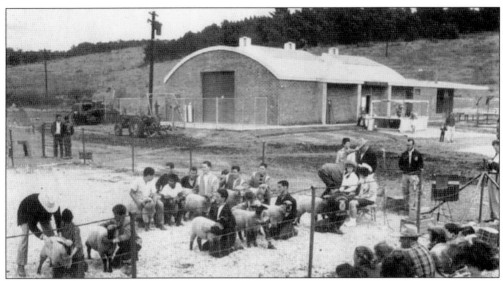

Todd Smith, John Carney, and other unidentified students in Karl Bakken's Future Farmers of America (FFA) group at Fallbrook High School showed their sheep in preparation for judging at the 1962 Del Mar Fair. The building in the background was the newly constructed Ag Building, located at the north end of the football and track field. (Courtesy of FHS.)

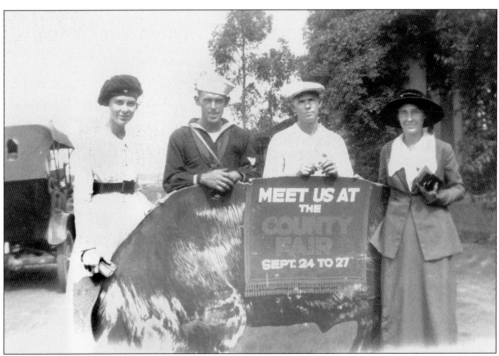

Pictured here, from left to right, Lucy Lamb, Ross Peters, Ray Peters, and Annie Lamb, behind a cutout sign painted to look like a hog, invite the community to meet them at the San Diego County Fair. D. O. Lamb worked with the Farm Bureau and the Chamber of Commerce of Northern San Diego County to organize the first San Diego County Fair.

This is the program for a minstrel show. The cast included the following families: Shipley, Lamb, Crane, Walker, Smelser, Sprouse, Masheeco, Stubblefield, Morris, and Butcher.

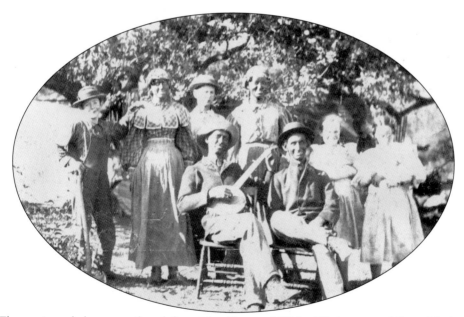

These minstrel players are, from left to right, (first row) Walter Wickerson and Cyrus Mackimons; (second row) Dora Hindorff and Newcomb; (third row) Con Keeler, Node Keeler, Eric Hindorff, and Leora Hindorff. The students were all from Rainbow.

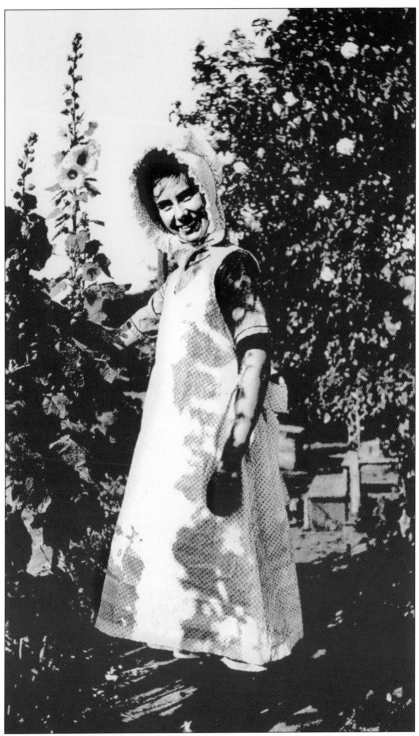

Lucy Lamb is dressed in an apron and sunbonnet for a play. Note the blooming hollyhocks and camellias. During this era before television and other electronic devices, people enjoyed plays, storytelling, and social interaction for entertainment.

Seven

THE REST OF THE STORY

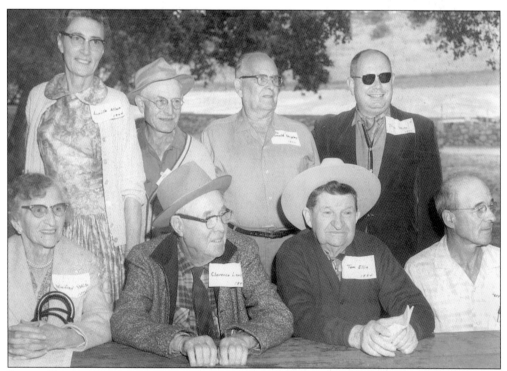

Pictured here at an old-timers gathering in 1962 are, from left to right, (first row) Winifred White, C. E. Lamb, Tom Ellis, and Elmer Allen; (second row) Lucille Allen, Fred White, Ronald Shipley, and David White. (Courtesy of FHS.)

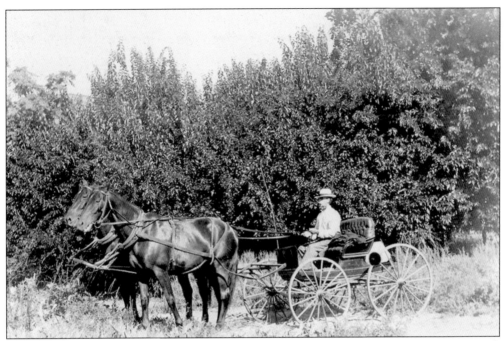

William Gird is pictured here in his buggy. Before going on a jaunt, the horses were fed, groomed, harnessed, and hitched to the wagon. Horses required daily care, exercise, and feeding, and families often had horses for different tasks—a workhorse pulled plows and helped in farming while a carriage horse pulled wagons or buggies.

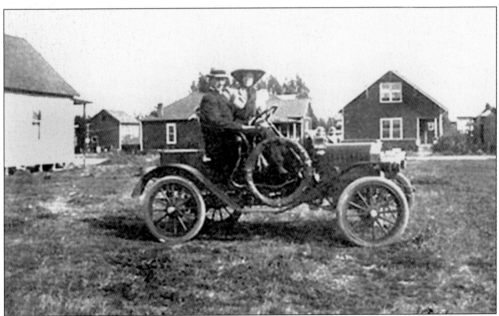

Charles and Dora Stubblefield of Rainbow show off a 1911 Maxwell car. Their son Edward was born and raised in Rainbow on the ranch Dora's parents homesteaded. Their three grandchildren were also born in Rainbow.

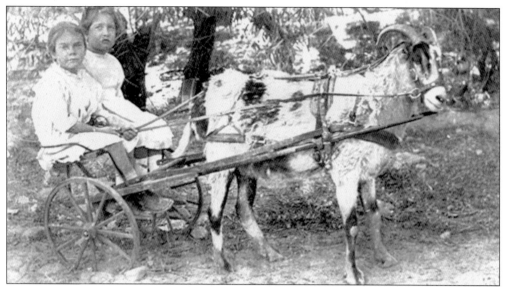

Sisters Betty and Maxine McEuen catch a ride on a cart pulled by a goat. Their father, William E. McEuen, most likely rigged up the goat and wagon to amuse his daughters.

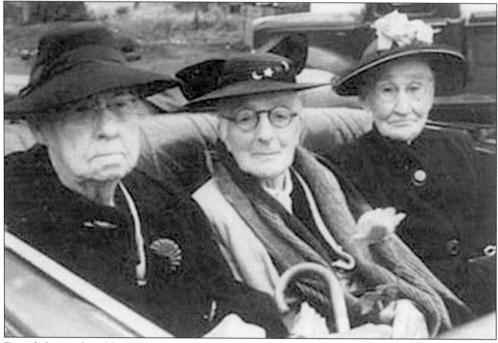

From left to right, old-timers Lucy Lamb, Edith Reche, and Maggie Kolb ride in an open touring car during the first Pioneer Day Parade in 1948. The day included a pancake breakfast hosted by the Lions Club, a rodeo at Fallbrook Riders Field, and a barbecue in Live Oak Park. (Courtesy of FHS.)

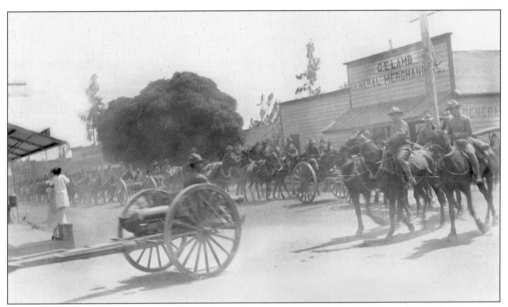

After World War I, the cavalry came through town, stopping for lunch at the Red Mountain Ranch, owned by George Houk, and then camping at Vail Ranch in Temecula for the night. Everyone went to watch the commotion as men and horses went through town.

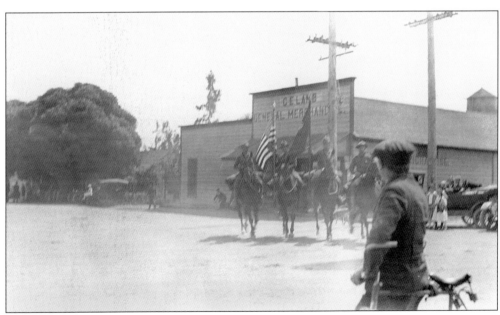

The company of soldiers came from Camp Kearny with cannons, tanks, and other equipment. The camp was south of the Red Mountain ranch house, on the hill across the ravine and creek. On another occasion, all the men who were not enlisted were asked to form squads and march down Main Street as a practice drill in case of emergency.

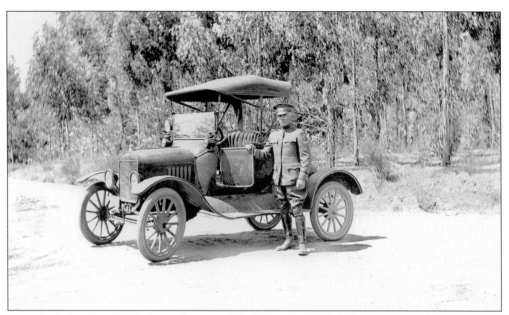

Capt. Jack Graffin, a U.S. Army doctor in World War I, stands by his Ford at Colestock Grove. He was married to Edna Lamb, and their only son, Phelps Graffin, was born in New Mexico in 1920.

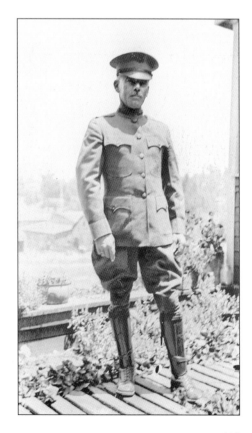

Captain Graffin died from typhoid fever in Shiprock, New Mexico, while he was helping the Native Americans during the epidemic. His widow, Edna Lamb Graffin, returned to Fallbrook with their infant son.

This is John G. Lamb, as he looked in his World War I army uniform. When men were drafted for service in World War I, families were allowed to keep one son home to help with farming. John was chosen to go because his older brother Murray was more help to the family and his younger brother was only 14 years old.

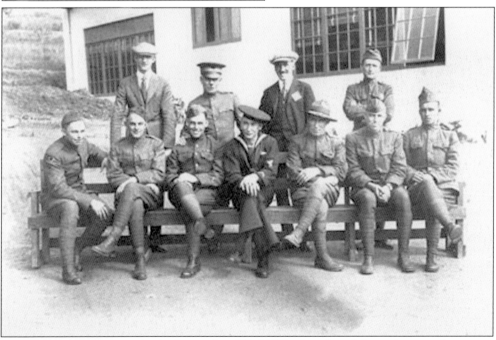

In 1918, a group of men who had served in World War I gathered for a photograph next to Fallbrook High School on Hawthorne Street. Each of them had attended school there before the war. (Courtesy of FHS.)

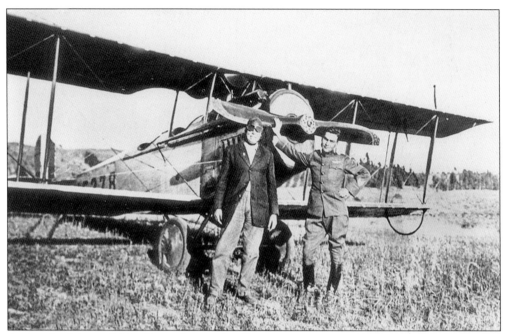

Army pilot Maunsell Van Renssalear, right, flew a practice run to Fallbrook in 1918 to see his parents. Bill Fleshman, town constable, donned goggles to go for a ride. (Courtesy of the Heath-Watkins collection.)

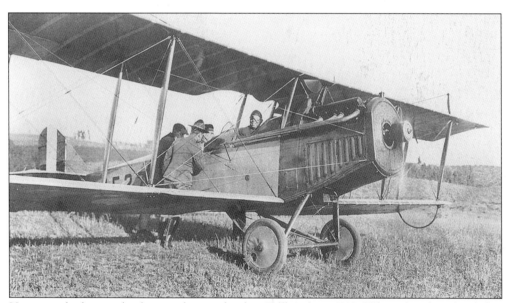

Here men look over the first airplane to land in Fallbrook in 1918. When the plane landed at Rancho Santa Margarita, on the mesa near Fallbrook, people drove over to see the curious "flying machine." (Courtesy of the Heath-Watkins collection.)

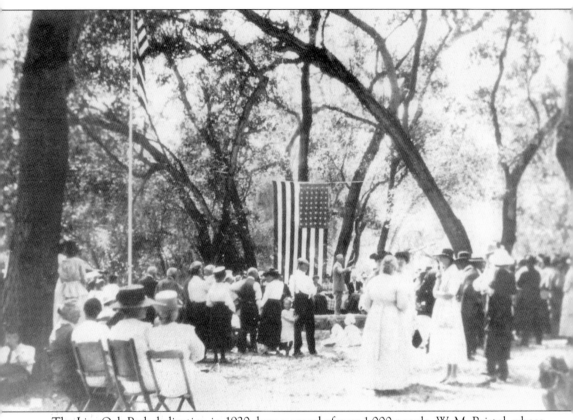

The Live Oak Park dedication in 1920 drew a crowd of over 1,000 people. W. M. Bristol, whose picnic tables at Camp Cajon inspired the replicas at Live Oak Park, presided over the event, which included speeches and instrumental and vocal music.

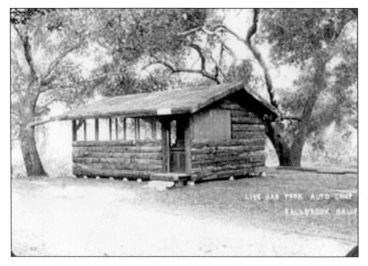

This is the log concession store at Live Oak Park, built by Eric Hindorff and run by Eric and his first wife, Pearl. They sold supplies to tourists who stayed at the automobile park in the 1920s for 25¢ a night. Live Oak Park had a dance floor, and people came from all over to go to the dances there.

This 1910 postcard photograph captures the beauty of Reches Grove, later christened Live Oak Park. The road, built by D. O. Lamb and now called Gird Road, crossed Fallbrook Creek on the Lamb Ranch, leading up through the canyon to meet the road at Reches Grove. The Lamb children walked a mile down the road to school everyday.

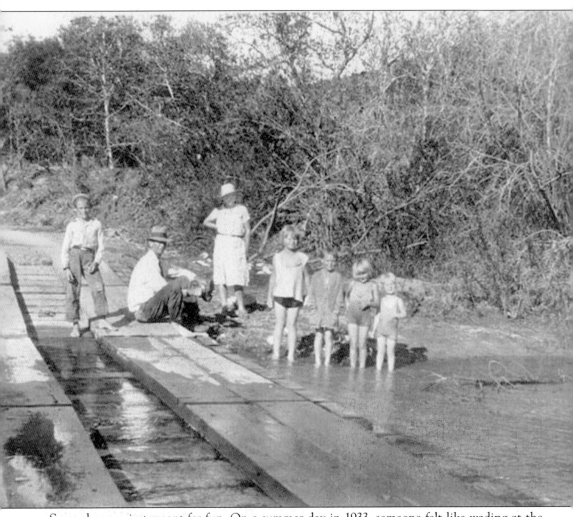

Some days are just meant for fun. On a summer day in 1933, someone felt like wading at the DeLuz Crossing. Pictured are, from the left to right, Jim McEuen, Eric Hindorff, Annie Hindorff, Margaret Hindorff, Marian Morse, Frances Hindorff, and Laura Hindorff.

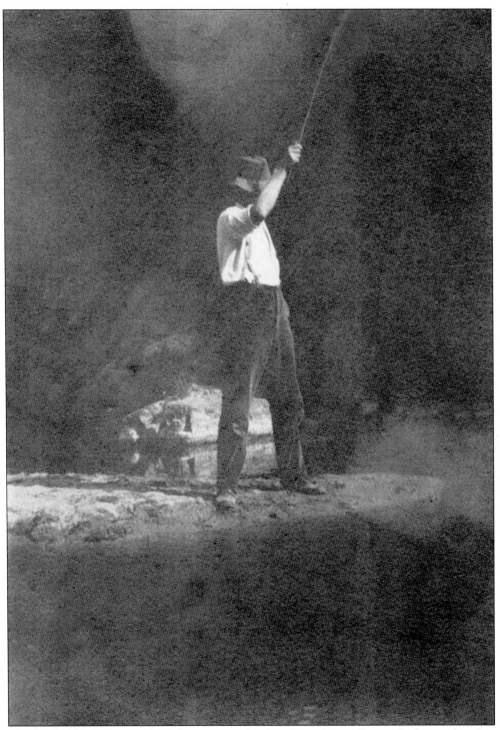

Charles Stubblefield, a serious fisherman, cast his line from the sandbar at the big pool in San Mateo, c. 1910. Fishing was not just a hobby, it also provided food for meals. Stubblefield's dramatic movement makes him look like the conductor of an orchestra.

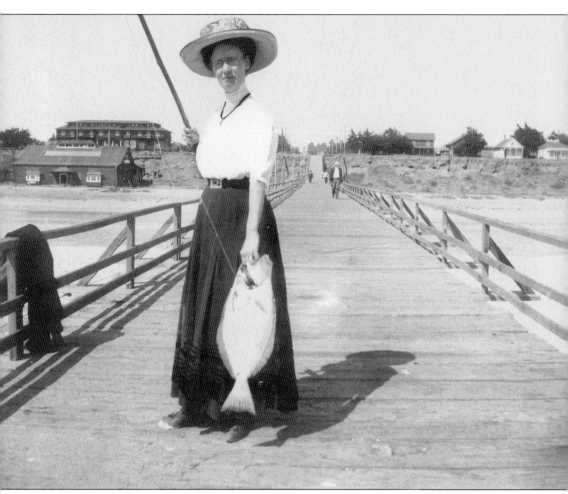

Pearl Hindorff holds the large fish she caught from the Oceanside Pier. Life was hard and all too short, but people in times past found joy in simple pleasures. Catching that fish was a real achievement, one that gave a tasty reward later.

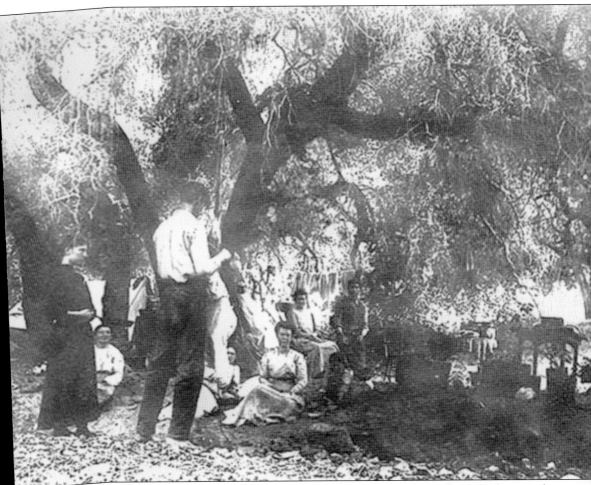

Eric Hindorff played his fiddle for fellow campers at San Mateo in 1910, and the legacy of music from the old-timers still comes to the ears of those who venture to imagine their tunes. Everyone can learn from the lives of those gone by, but can also leave their own footprints. Talk to older people. Record memories on film and on paper. Label photographs. Talk to children. Donate money or volunteer at the Fallbrook Museum. Share the music, hum the tune, and let the music continue.

ACROSS AMERICA, PEOPLE ARE DISCOVERING SOMETHING WONDERFUL. *THEIR HERITAGE.*

Arcadia Publishing is the leading local history publisher in the United States. With more than 3,000 titles in print and hundreds of new titles released every year, Arcadia has extensive specialized experience chronicling the history of communities and celebrating America's hidden stories, bringing to life the people, places, and events from the past. To discover the history of other communities across the nation, please visit:

www.arcadiapublishing.com

Customized search tools allow you to find regional history books about the town where you grew up, the cities where your friends and family live, the town where your parents met, or even that retirement spot you've been dreaming about.